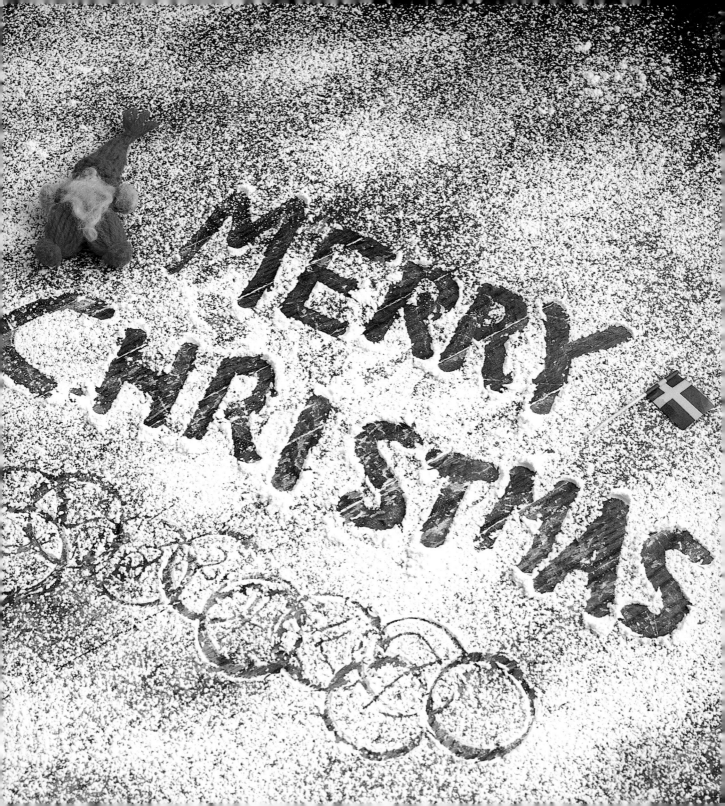

SWEDISH CHRISTMAS
© Copyright text and recipes Catarina Lundgren Åström
© Copyright photo Catarina Lundgren Åström and Peter Åström

English translation: Roger Tanner, Ordväxlingen AB, Sweden
Printed by: Fälth & Hässler, Värnamo, Sweden 2002
Binding: Fälth & Hässler, Farsta, Sweden 2002
Paper: Euro Bulk 135 g
Publisher: Bokförlaget Arena

ISBN: 91-7843-177-8

CONTENTS

Swedish Christmas

Preface

➡ I'll never forget my childhood Christmases. They were fantastic. I grew up in the country, in a small village in Västergötland, just over 100 km from Gothenburg (Göteborg). As in so many Swedish homes, our Christmases were full of traditions that had been handed down from one generation to another.

Everything was carefully planned. All the hundreds of Santas my mother had accumulated had their appointed places. Some were heirlooms, others had been bought, some were hand-crafted of wood and others were mass-produced in porcelain.

Some were beautiful, others less prepossessing. But they all had to be displayed. The Christmas tree was always in the same place, always had the same decorations–colored balls, crackers and Santas–and was always dressed the day before Christmas Eve. There was nothing peculiar about all this. All our neighbors did exactly the same thing. Our relatives too. In fact everyone I know in this far-flung country of ours has their own little set rituals which they would never dream of altering. For innovations and alterations hold no attraction for the Swedes where Yuletide traditions are concerned. Otherwise we are quite keen to change with the times.

No, Christmas is sacrosanct. Nothing about it changes, and sometimes this may cause a few minor disturbances when new members enter the family and try bringing their own habits and customs with them.

And a Swedish Christmas is a long-drawn-out-affair, starting with Advent at the beginning of December and not ending until Hilarymas on 13th of January, when people "dance out the Christmas" and throw out the Christmas tree, which by this time is looking somewhat the worse for wear. Ever since I was a small girl, Christmas has been the highlight of the year. Because it's a time of fixing and making, decking and baking. Every day has its particular tasks, so that everything will be ready by Christmas Eve. Christmas Eve is the biggest day of the whole festival in Sweden. That's when Santa Claus arrives with a sack full of Christmas presents, and that's when the great Christmas table springs into action.

I must confess that as a child, the food didn't interest me at all. It seemed to me that the adults just kept stuffing themselves and the hands of the clock would never make it round to four p.m. and the arrival of Santa Claus. Not to mention the preceding night, I didn't sleep for much of it. I spent most of the time twisting and turning, terribly nervous over the impending response to the formida-

ble wish list I'd sent off to Santa Claus.

And was it really Santa Claus who did all the shopping? After all, most of the parcels were hidden in a big Santa Claus sack down in the boiler room. And how on earth did Santa Claus get hold of the parcels which I had bought and so carefully wrapped up for Mom and Dad? For a small child there were so many things that just didn't add up. One thing I did know, however – Santa Claus did really exist. He lived in the forest with his elves. He had a long grey beard, a red hood and a red jacket, and he tottered along with walking stick and lantern. He seemed incredibly old. A hundred years old, easily.

To an outsider, Christmas celebrations in Sweden must seem interesting but at the same time puzzling. What exactly are these people up to, dressing in white gowns, going around with lighted candles in their hair and singing a song about Santa Lucia? Then they drink a kind of sweet wine called glögg, they eat far too many ginger snaps and they cook up a storm. And as if

this weren't bad enough, they go dancing around the Christmas tree pretending to be frogs.

Yes, I can understand the outsider's concern for our mental health. But the purpose of this book is to straighten out the question marks into exclamation marks. And of course explain our Swedish customs and habits. I have deliberately avoided the religious side of Christmas celebrations, concentrating instead on the folklore aspect. How do you celebrate a Swedish Christmas, even on American soil? The fragrances, the flavors, the lights and the Santas can all be evoked. I try to give my own daughter the same Swedish Christmases as I myself once experienced. The same mystery the same excitement and longing, even though we are now living in the USA. I want her to preserve her Swedish roots in the midst of American life. And we aren't the only ones. There are many people of Swedish descent in the USA. In fact, they outnumber the Swedes in Sweden!

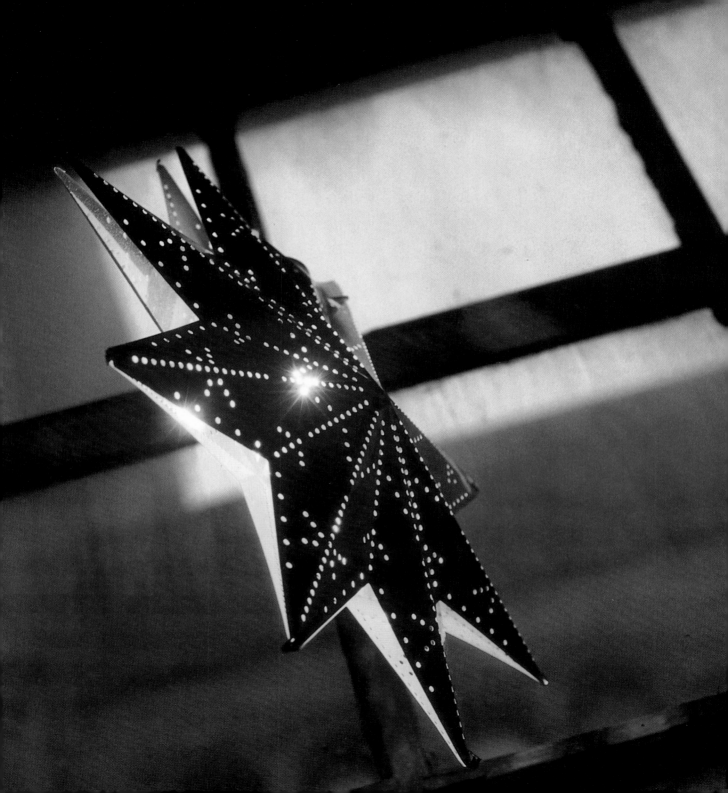

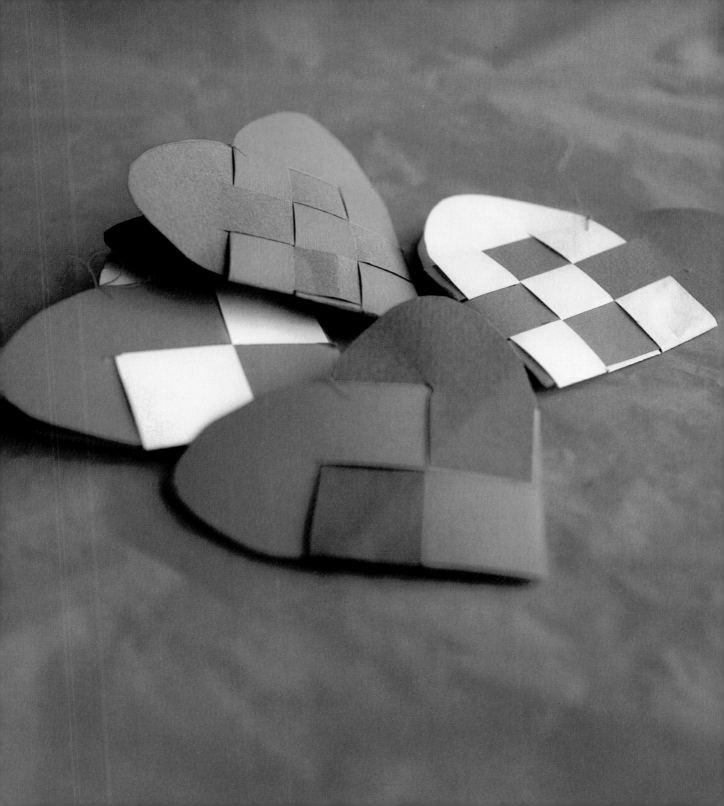

The First Sunday in Advent

▶▶Christmas already comes knocking at the door on the first Sunday in December, and at times, the last one in November. This is the first Sunday of Advent, when the countdown to Christmas Eve begins. The Advent candelabra are brought out, a very special design holding four candles, one of which will be lit on the first Sunday, two on the second and so on, right down to Christmas Eve. There are many different versions of candelabra. Some have a kind of cavity which you fill with moss and small artificial toadstools. Others are made of wood, cast iron, copper or bronze. Whatever the model, it's always the same old candleholder you bring out, year after year. Lighting the first candle is a wonderful feeling, because then you know that Christmas is near. You are assured of some lovely weeks ahead and a whole battalion of smells, memories and expectations passes through your mind. Of course you also know that the days ahead are going to be very busy ones.

There are four whole weeks until Christmas Eve, but this is barely enough for everything that has to be done. Food has to be prepared, glögg drunk, ginger snaps and "Lucia buns" baked, Lucia celebrated, presents bought and decorations made with the assistance of the smallest members of the family. The entire home has to be filled with a Christmas atmosphere. The first Sunday of Advent doesn't just mean lighting the first candle. A lot of people jump the gun for a preview of Yuletide delicacies. When I was a child, my grandfather used to treat the whole clan to the Christmas smorgasbord at Stora Hotellet (Grand Hotel), Jönköping, a few miles off in Småland, the southern province of deep, dark forests. How we gorged ourselves! Blissfully replete, we then went forth to do the rounds of "Shop Window Sunday." All the shops had specially arranged their windows for the occasion on the self-evident theme of Christmas. So there you stood, wistfully squashing your nose against the toy shop windows. There were so many things I wanted. We bought lottery tickets, and I remember one year winning a Christmas ham, though I would rather have had that big teddy bear. But at least it made Mother happy.

The major attraction in Stockholm has always been the windows of the NK department store. Every child's dream, and highly reminiscent of the displays put on by Macys, Lord & Taylor and Saks in New York.

Nowadays most shops stay open on Sundays, and Christmas shopping gets off to a flying start. But when I was small you had to make windowshopping, because the idea of shops opening on Sundays in those days

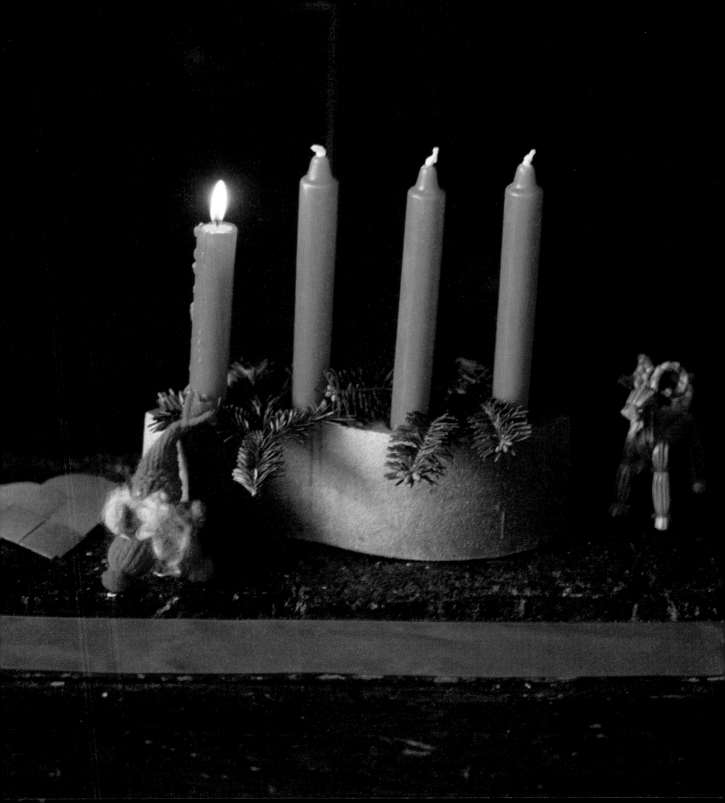

would have been quite outrageous.

The first Sunday in Advent is also the day when the Christmas fairs get started. The best known of them in Stockholm are in Stortorget, Gamla Stan (Old Town), and at Skansen. From small red booths you can buy anything from newly dipped candles, to straw craft, home-made bread, fresh made buns, and hot glögg spiked with raisins and almonds. If you're lucky there will be a sprinkling of snow on the ground. All Christmases reside in the nostalgic memory of snow-covered landscapes, but the brutal fact is that they have sometimes been merely greyish-green, with snow flakes a figment of wishful imagination. Sweden may be at the north-ern end of the map, but this is no permanent guarantee of snow. Even without snow, it can still be bitter cold.

Windows are hung with electric Yuletide stars, a tradition imported from Germany in the 1930's. One of the first to perceive the money-spin-ning potential of Advent stars in Sweden was Erling Persson, who went on to found the Swedish H&M chain of fashion stores. In the mid-1940's, he and his business partner saw to it that most homes in Sweden were lit up by the pleasant glow of a simply constructed collapsible yel-low-red star. Originally it had a built in paraffin lamp, later to be super-seded by a filament bulb. It was an unqualified success. Today there are

stars of many shapes and sizes, some made of cardboard, others of metal, but you can also find them made of straw and wood.

Stars, though, are not the only window decorations. In recent years they have come in for stiff competition from the hugely popular electric candelabra. Most of these feature five or seven lights—reminiscent of the Jewish Menorahs of the electric variety. Every Swedish home has at least one, and many have several. To the foreign visitor, looking up at a Swedish apartment block can be quite a remarkable experience. Hardly a window without its star or candelabra. During the 1990's, the candelabra were selling at a rate of a million per annum.

The first day of December also marks the opening of the Christmas calendar, which was also a German invention. At the beginning of the 20th century, a young boy called Gerhard Lang kept pestering his mother to tell him how many days were left to Christmas Eve. Eventually she hit on the idea of baking 24 buns numbered from 1–24. Anything for a quiet life. Later on, Gerhard, now a businessman, recalled his mother's ingenious way of shutting him up. Using two sheets of paper, he constructed a calendar which had 24 little flaps with figures hidden behind them. That was in the 1920's. I went through any number of those calendars in my own childhood. Some even had pieces of chocolate hidden behind the flaps. But the most enjoyable of them was the Swedish Television Christmas Calendar, a specially made series in which, every day, there was an episode based on whatever was hidden behind the flap of the day. I remember sitting there, day after day, riveted to the television set. For at that time, Swedish Television had only one channel, and children's programmes were allotted only half an hour daily out of its precious transmitting time. The television Christmas Calendar gathered speed in 1961, but six years earlier Swedish Radio had already hit on the brilliant idea of interlinking the calendar with children's radio broadcasting. It was a winner. No fewer than 360,000 calendars were sold in 1962, which was rather impressive in a country with a total population of just under 8 million. Even today, Swedish children won't miss their Christmas Calendar on television for anything.

In addition to the televised Christmas Calendar, I loved the calendar which my mother and grandmother put together using 24 small packets. Every morning after breakfast I was allowed to open one of them. With bated breath, I variously discovered hair clips, chewing gum, and lollipops.

Glögg and Ginger Snaps

▸ Around the first Sunday in Advent, the glögg parties move into high gear. Everyone loves the idea of warming themselves with a glass of hot glögg in congenial company, though in moderation. Glögg is sweet, and lacing it too hard with vodka can leave you unsteady on your feet.

Glögg can be compared to the German Glühwein, familiar not least to those who have been on alpine skiing holidays, when a warming glass of Glühwein is usually what to be ordered after a day on the slopes. In Sweden, the atmosphere of Christmas, with candles, electric candelabra and Christmas stars, is sufficient in itself to trigger the appetite for glögg. Until just a few years ago, glögg was mostly made with red wine, but now the white version, made with white wine, has taken over almost completely. Glögg can also be made with a syrup of spices boiled in beer and then mixed with sugar, vodka and wine. This mixture is perhaps the most insidious of them all. And if you're on the wagon – driving, for example – a perfectly acceptable glögg can be made using apple- or grapejuice.

It's the spices that give glögg its characteristic flavor. Cinnamon, cloves, cardamom and raisins, with sugar added, are the foundation of most recipes. Almonds, usually blanched, and raisins are the standard accessories, poured into the glass with the hot glögg itself.

The tradition of drinking glögg at Christmas time goes back more than a hundred years. But the practice of spicing wine goes back to the 16th century. In those days it was more a matter of trying to conceal the taste of wines which, imported from the Continent, did not always travel well. Added to which, spices were credited with the power of curing everything from bruises and diarrhea to constipation, toothache and melancholy. Probably the reason why the mixture was heated was that, our climate being what it is, we shunned no opportunity of banishing the cold.

The actual name glögg comes from an old method of making the drink: you "glowed" it. First you put a sugarloaf on a closed-meshed grille over a cooking pot containing the mixed spices, and then over this you poured wine and spirit. When the sugar was saturated you struck a flame, whereupon the spirit caught fire and the sugar melted. You then continued pouring on the mixture of wine and spirit until all the sugar had melted. The result is a delicacy indeed, but the method demands both patience and caution.

There can be no glögg party without the ginger snaps, the spices for which are very

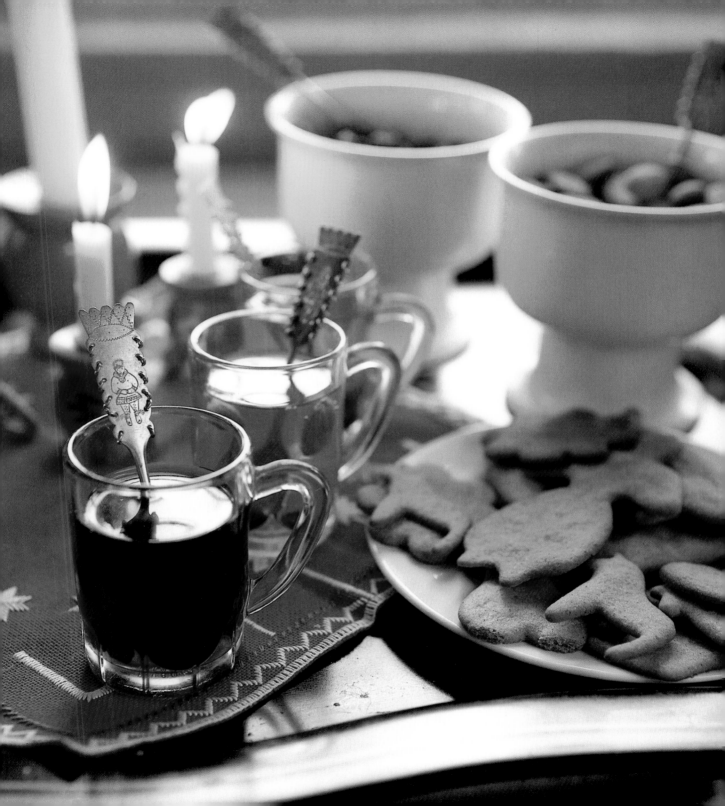

much the same as those in the glögg. The best thing about ginger snaps is that you can gorge yourself with them without any qualms of conscience, because – so we are told – the eating of ginger snaps is conducive to a kindly disposition.

For a new way of eating ginger snaps, try spreading blue cheese on them and washing them down with a glass of glögg. Sensational!

The first Swedish recipes for these "medicinal" ginger snaps appeared at the end of the 15th century. In those days they were baked with real pepper. Like so many other Christmas traditions in Sweden, ginger snaps came to us by way of Germany. But people were already baking with strong spices in Egypt 4,000 years ago, so ginger snaps aren't exactly a new invention. The typical shapes for them–pigs, old men, old women and hearts–only came in during the 19th century, though, as a tin-smithing sideline. As a child, I remember being given my first ginger snap cutters by a dear old local tinsmith. They still do service when the time comes round for the mandatory baking session. The recipe I use has been handed down in our family and is unique in that all the ingredients are boiled together. The smell from the pot is heavenly. But it's hard work, making ginger snaps. Rolling the dough wafer-thin is a severe test of patience.

As we move still closer to Christmas, a new ginger snap dough has to be made, this time for the building of a gingerbread house. An exacting task of precision engineering, not least because it's very easy to burn yourself on the molten sugar adhesive. So for this particular stage of the operation, keep the children at a distance. But then they can really go on with the icing, covering the house in "snow", hanging it with icicles and so on.

Every year when I was small, my mother used to compose an entire Christmas landscape round the gingerbread house, with a tobogganing slope for the santas and elves, cut out of a shoe box. The shoe box was put on top of a chest of drawers and filled with cotton wool for snow. When all the snow had been carefully distributed, the gingerbread house was put back in place and all the santas carefully stationed on the slope and round about. I loved that Christmas landscape. I used to spend hours playing with the santas on the slope and letting my imagination run wild. Even today I still get a kick out of placing them in the snow, now in the company of my own daughter. I can't help smiling when I see how eagerly she plays with them. It takes me back to the time when I myself would enter that little santa world.

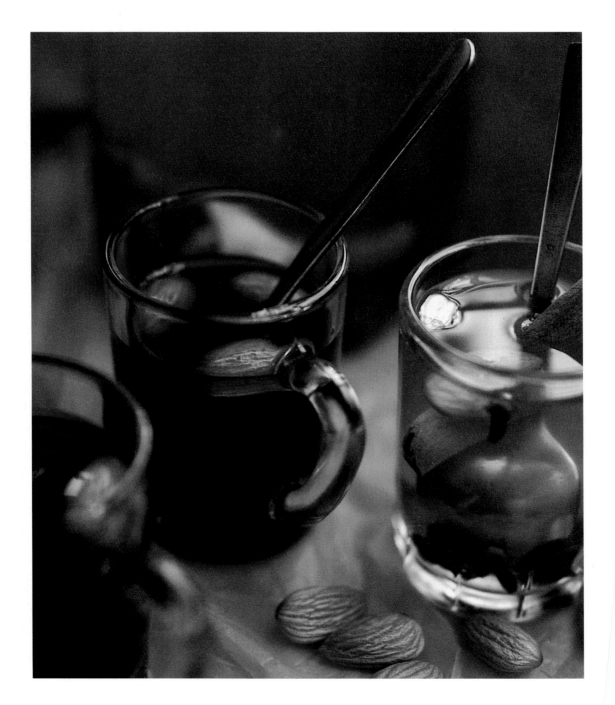

GLÖGG

Hot glögg, consisting of wine, spices and sugar,
is the first sign of approaching Christmas.

Red or white wine glögg

1 bottle of red or
white wine
1/2 cup sugar
18 whole cloves,
8 whole cardamom pods
1 cinnamonstick
1 piece of ginger,
approx. 1 inch
Serve with raisins and
almonds.

- Mix wine, sugar and spices, then heat
- Turn off the heat when the sugar has melted.
- Cover and leave to stand for an hour. Strain off the spices if you like.
- For a stronger version, add 4 oz vodka or cognac.

Non-alcoholic glögg

4 cups of apple juice
or grape juice
1/4 cup sugar
18 whole cloves
8 whole cardamom pods
1 cinnamonstick
1 piece of ginger,
approx. 1 inch
Serve with raisins and
almonds.

- Procedure: same as for wine glögg.

GINGER SNAPS

Eating ginger snaps makes you good-natured, or so the saying goes. So why not assemble the whole family round the baking table one afternoon and let your imagination rip with the pastry cutters?

5 1/2 oz butter
2/3 cup sugar
1 tbsp. ground ginger
1 tbsp. ground cloves,
1 tbsp. ground cinnamon
1 tbsp. baking soda
1 egg
3 1/2 cups all-purpose flour
oven temperature: 400°F

- Heat the butter, sugar, ginger, cloves, cinnamon and baking soda together and stir into a paste.
- Leave to cool before adding the egg.
- Mix in the flour to make a dough.
- If possible, leave the dough in the fridge for an hour or so.
- Roll out a suitable portion of dough, wafer-thin, on a pastry board. Make patterns with pastry cutters, or compose your own with a knife.

- Transfer the snaps to a greased baking tray and bake for 4–6 minutes. Keep an eye on them –they burn easily.

Icing

2 1/2 cups powdered sugar
1–1 1/2 white of eggs
add a few drops of distilled vinegar or lemon

- Mix the powdered sugar and white of egg to form a batter.
- Add a few drops of distilled vinegar or lemon juice.
- Transfer the mixture to a plastic bag.
- Make a little hole in one corner.
- Now squeeze out your pattern(s) onto the ginger snaps.

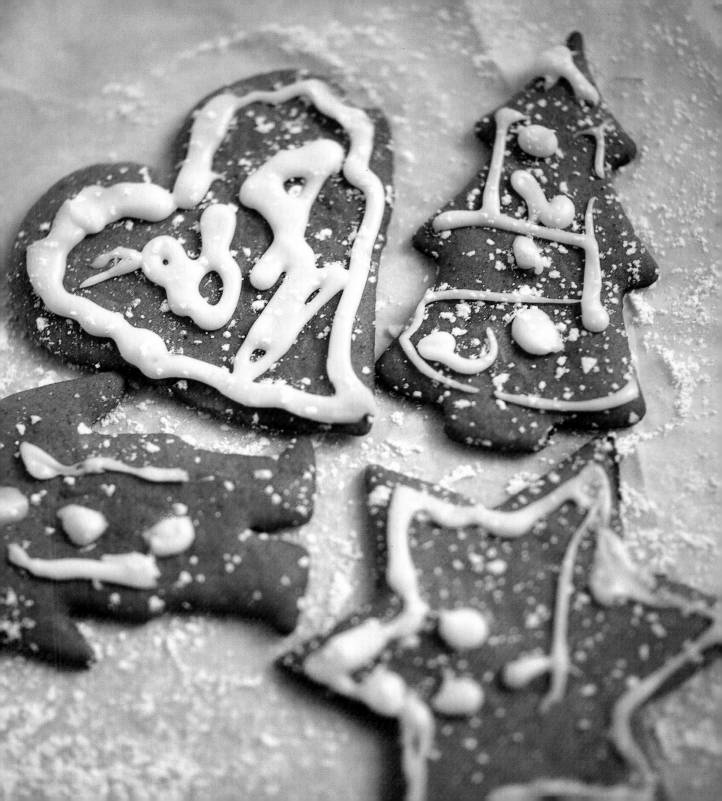

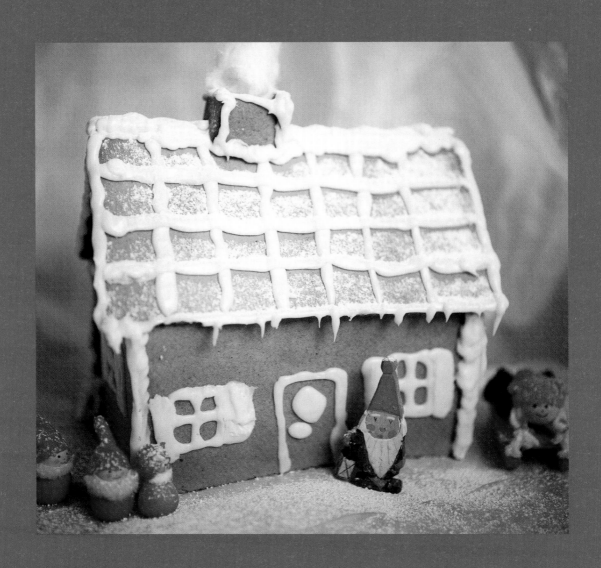

GINGERBREAD HOUSE

Gingerbread house-building is fun for young and old alike. Let your imagination rip. If you fancy building a house like the one in the picture, the measurements are on page 150.

1 1/4 cups sugar
1 cup corn syrup
5 oz butter
1 tbsp. ground cinnamon
1 tbsp. ground ginger
1 tbsp. ground cloves
1 tsp. baking soda
1 1/4 cups water
about 7 cups
all-purpose flour

Oven temperature: 440°F

- Melt the sugar and syrup in a saucepan over a low flame, stirring until the sugar dissolves.
- Add butter and stir until melted.
- Transfer to a mixing bowl and leave to cool.
- Mix the spices and bakingsoda in water in another saucepan. Mix well before adding to the sugar mixture.
- Pour on the flour and make a dough.
- Roll out the dough directly on a greased baking sheet and cut out the components for the house.
- Start with the big bits, and bake them before doing smaller details like the chimney.
- After baking the different parts, trim them if you like before they have cooled completely.
- Glue the house together, e.g. with sugar melted in a frying pan. WARNING! This gets very hot and you can very easily burn yourself, so be careful. Keep the children out of this stage. They can help with the frosting, it's safer.

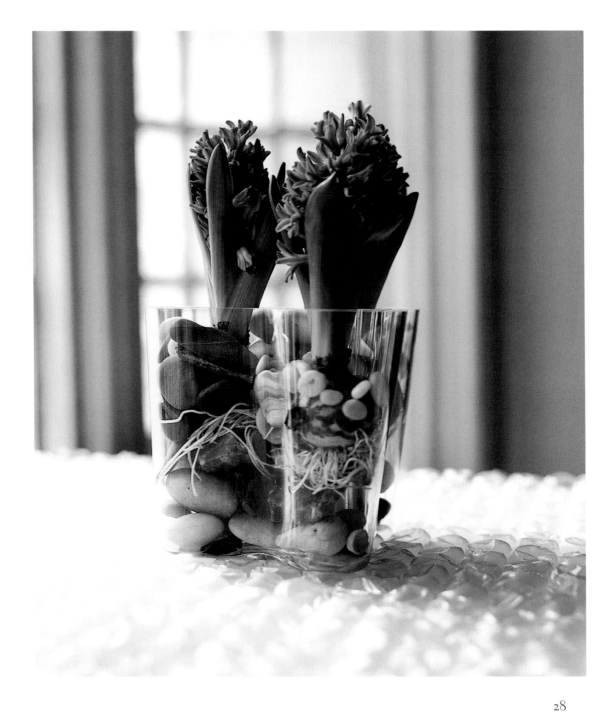

The Run-Up

▸▸Hardly has the first candle been lit in the Advent candelabra and the first glögg tested, when the home becomes a flurry of pre-Christmas activity. December is full of tasks to be done, and many of them have to be done on particular days to meet the Christmas deadline. Every day in the Swedish calendar is a name day, when the people with those names are regaled with cake. It's rather like having an extra birthday. On 9th of December–"Anna Day"–the stockfish has to be soaked in water so as to be ready in time. Stockfish can be various kinds of fish–ling, cod and saithe, for example–which, after they have been caught and gutted, are hung up to dry and later soaked. Originally this was an excellent way of storing fish during winter, when the thick ice made fishing difficult. In those days lutfisk, to use it its Swedish name, was poor man's fare, whereas today many people regard it as an essential Yuletide delicacy. Not that everyone enjoys its rather jelly-like consistency. I remember hating it as a child and sticking to the potatoes and the white sauce. Today I love it. The procedure involves soaking in various liquids. First water, then lye and then water again. By starting on Anna Day, you end up with a fish that is perfect for eating on Christmas Eve.

Lutfisk is said to be perfect for dieters and, thanks to its basic consistency, a sure cure for gastric ulcers. As for serving it, there are many schools of thought. Some say that a white béchamel sauce, potatoes and white pepper are all you need. Others insist on green peas and/or coarse ground mustard or mustard sauce. But not many people nowadays do their own lye-soaking. Buying the fish ready made from the shop is much more convenient. Then all you have to do is put it in the oven or boil it on the stove. In Swedish Ikea furniture stores at Christmas time, if you're lucky, you can find lutfisk in deep-frozen packages, but otherwise it's conspicuous by its absence in American stores.

Nobelday

▶▶The day following Anna Day features another event which perhaps hasn't directly to do with Christmas but should be mentioned all the same. It is Nobel Day, which is the presentation day for the Nobel Prize. Founded by the chemist and inventor Alfred Nobel, the man behind both the detonator cap and dynamite. The great fortune he accumulated in his lifetime he bequeathed to a fund, the yield on which finances the prizes. The laureates receive the money, with a medal and diploma, from the hands of King Carl XVI Gustaf of Sweden at a ceremony in the bright blue Concert Hall in Hö-torget, Stockholm. The Nobel Prize is awarded for physics, chemistry, physiology or medicine and literature. An economics prize was added in 1969, and there is also a Peace Prize, presented in Oslo. The first award presentations took place in 1901. The ceremony always takes place on the 10th of December, coinciding with the anniversary of Alfred Nobel's death.

After the presentations the Nobelfestivities continue in the Stockholm City Hall, with a Banquet served on specially designed Nobel service complete with specially made Nobel cutlery and Nobel glassware. The delicacies served are usually a well-kept secret right up to the last minute. The highlight of the evening is the processional entry of the ice cream. This is a real test of the skills of the waiting staff, moving down the grand staircase with works of art–trays of candle-lit ice cream— held high. Sometimes the ice cream literally glows. The banquet is followed by a ball. The prize winners always stay at Grand Hotel and, early the following morning, are usually awakened by a lovely white-robed being with candles in her hair–Lucia.

Lucia

Early on the morning of December 13th, Lucia stands in the doorway. She is dressed in white and wear a crown of candles in her hair surrounded by a brass crown, sometimes with a wreath of lingonberry twigs. Round her waist she has a red silk girdle. Lucia usually brings a tray of coffee and saffron-fragrant "Lucia Buns". Not infrequently she has a retinue, the girls also dressed in white but with tinsel in their hair, and the boys wearing tall, funnel-shaped hats (like dunces' caps) and holding stars in their hands. The arrival of this procession is a longed-for occasion, and the songs they sing are well-known, the best loved of them all being the one called Santa Lucia, which describes how Lucia enters the home, spreading warmth and light in the cold darkness of a winter's morning, which is, in fact exactly what happens.

It used to be believed that Lucia night was the longest night of the year, a magical night, full of superstition. This was also the night on which the pig had to be slaughtered and a dram (small drink of alcohol) given to the butcher. At the end of a hard-working night, they were liable to consume a few drams too many. Once the pig had been butchered, it was time for a hearty breakfast of pork, usu-

ally at the middle of night. Out came the mandatory vodka bottle yet again. But only for the men. The women, at most, would have the privilege of cooking the food, and perhaps cleaning afterwards while the men slept it off.

On the evening before Lucia Night, there would be a visit from the "Lussegubbar," men dressed up and playing the fool, and counting on food and a dram for their trouble. It's a tradition that lives on in the west of Sweden, where, on the evening before Lucia, the children dress up and go begging sweets, rather like the Halloween practice of Trick or Treat.

Lucia is a favorite tradition in practically every Swedish home. Every town crowns its own Lucia, as does every school and every day-nursery. For the very youngest, thank goodness, battery-powered lights have been substituted for the dangers of real candles. I still cringe at the memory of how it hurt when the melted wax ran down my neck and how awful it was afterwards, trying to get the stuff out of your hair.

Presently my daughter takes charge of the Lucia celebrations at home. She dresses up in a white shift dress with a Lucia crown on her

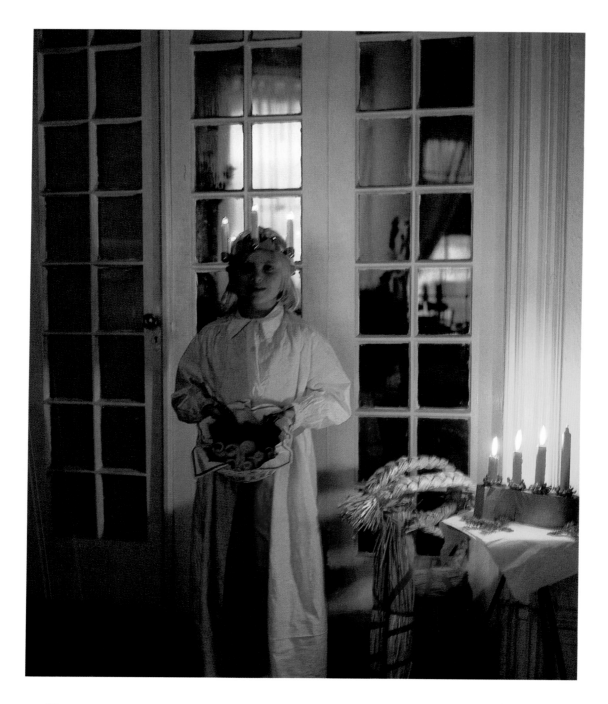

33

head, rousing us with coffee, buns and singing.

Sometimes I try on my old crown and relive being my school Lucia. It's clear, from all the questions I keep being asked that Swedish Lucia celebrations hold a special attraction for Americans. Everyone's curiosity is aroused by the white-clad, candle-haired woman we include in our Christmas celebrations. When the Swedish Church in New York holds its annual Lucia procession, the place is usually packed with both Swedes and Americans. Although an essential part of Christmas in Sweden, Lucia is a relatively new tradition, which perhaps explains why the people emigrating to America at the end of the 19th century didn't take the cus-tom with them. The first Lucias appeared in the west of Sweden during the 1890s, and Lucia's début at Skansen, Stockholm, took place in 1893.

The background story isn't alto-gether straightforward. The name comes from the Italian saint, Lucia, who was martyred in the 4th centu-ry and, just before she died, pierced both her eyes, sacrificing them for the conversion of a pagan. Nobody has quite been able to make out how she then became a part of Swedish Christmas celebrations. For the Swe-dish Lucia apparently has nothing in common with the saint from Syra-cuse, Sicily, except the name. If any-thing, Lucia seems likelier to have got her name from the Latin lux, meaning light. The song she sings is

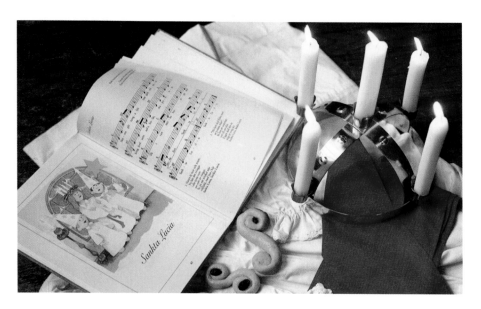

really a traditional song among Neapolitan fisherfolk. A Swedish composer, chancing to hear it while on a visit to Italy, brought the tune back home and fitted suitable Swedish words to it.

Prior to the broad tradition of Lucia over postcentury, older Lucias appeared in Sweden early as 1764 and had wings. She was probably a Swedish version of the German celebration of Kinkes Jes (Kindchen Jesus), for which people dressed up in a white shift, wore halos and proffered special buns. That custom died out in Germany during the 19th century, at about the same time the first Lucia appeared on manorial estates in Västergötland, Sweden, probably as a direct import of Kinken Jes. Students from western Sweden then took the custom with them to the university cities of Lund and Uppsala, whereupon Lucia started to catch on throughout the entire country. Its further propagation was partly due to the newspaper Stockholm Dagblad, which in 1927 hit on the brilliant idea of crowning a Lucia in Stockholm, a custom which rapidly became nation-wide.

Lucia buns, otherwise known as Lussecats, are only served around Lucia time. They come in many imaginative shapes, commonest of all being the "Christmas hog", S-shaped with an extra twist for the tail. Other classical shapes are "Priest's hair", Christmas cake and Lucia crown. Whatever the shape, they are all decorated with raisins. The custom of baking saffron buns for Lucia celebrations dates back not quite 200 years, to the time when cake-baking in domestic ovens first became feasible. We don't know exactly why people chose to add saffron. Perhaps because it looked fine or because, with Christmas approaching after the labors of autumn, they fancied a bit of luxury. And flavoring the buns with pistils from the saffron crocus was certainly a luxury. Saffron is expensive, almost the same price as gold. So it's just as well you don't need too much saffron to flavor and color the dough. And there is no point in adding extra saffron in the hope of improving the flavor still further, because then the buns will turn out as hard as rock and dry as dust. What a disgrace that would be!

Making Lucia buns is fun and an excellent opportunity for assembling the whole family in the kitchen. The dough smells wonderful and is easy to work with. And if you're feeling creative, you can make up Lucia bun shapes of your very own.

In times past, saffron was also used a great deal for medicinal purposes. It was also believed to be good for your love life, though in moderate doses. Purportedly, if you overdo it, the effects can be lethal.

35

LUCIA BUNS–SAFFRON BUNS

Lucia buns have a wonderful saffron fragrance, but saffron is expensive and if you overdo it they'll come out hard as a rock.

Makes 60–70

10 oz butter
4 cups milk
3 active dry yeast
1 gram of pure saffron
1 1/2 cups sugar
2 eggs
1/2 tsp. salt
12–13 cups all-purpose flour

1 egg–to beat and brush the buns before baking

Oven temperature: 480°F

- Melt butter in a pan, pour on the milk and heat to 98.6°F.
- Stir in the yeast, making sure it dissolves completely.
- Crush saffron in a mortar and mix in some from the milk mixture to blend it.
- Pour back into entire milk mixture.
- Add sugar, salt, the whisked eggs and 7 cups of the flour, stirring to a dough.
- Transfer the dough to a floured pastry board and work in the rest of the flour.
- Put the dough in a bowl, cover with a cloth and leave to rise for 40 minutes.
- Knead the dough and divide into six pieces.
- Take part of the dough, roll it out and cut into ten pieces, rolling each one to about 10 inches. Shape into a twirly-ended letter S, with a raisin in the middle of each twirl.
- Place the buns on a greased baking tray, cover with a cloth and prove for 30 minutes.
- Brush with beaten egg. Bake for about 5 minutes, until you like the color.

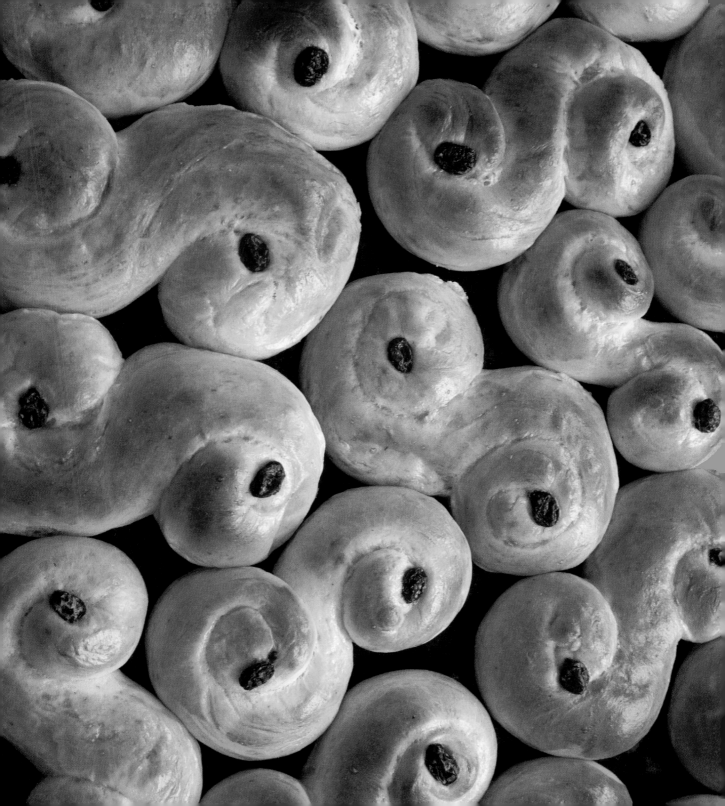

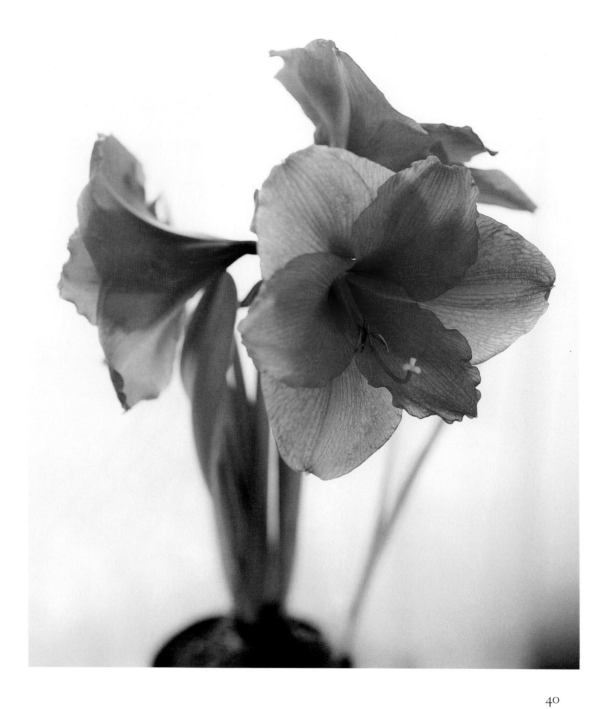

Christmas Crafting, Christmas Flowers and Other Social Occasions

▸▸With Christmas approaching, practically every home and cottage in Sweden is a hive of industry. Everyone wants to get things nice and shipshape for the approching festival. This needn't just mean cleaning and tidying. It can also mean gathering the whole family round a table to make Christmas decorations, the more classical of which include braided hearts, which can be made in various sizes. They are just the thing for hanging on the Christmas tree. Nearly all Swedish Christmas tree decorations include at least one or two hearts. Cardboard angels are another easy and popular decoration, and another essential is crackers made of brightly colored tissue paper, the predominant color, of course, being red for Christmas. Take two differently colored sheets of paper, one on top of the other, roll them thin or fold them to a suitable size, then cut narrow strips halfway across the paper or else part way from each side and then shake. A bookmark or a small strip of gold paper will do for embellishment. Later on in this book you will find more detailed instructions for making your own crackers and braided hearts.

People also used to amuse themselves at home by crafting things out of straw. Most folks today prefer buying these things ready-made, straw being a rather uncooperative material to work with. There are any number of straw articles, ranging from small hearts, angels and stars to be hung on the Christmas tree to big Christmas goats and belfries. You won't find many homes that don't have a Christmas goat standing next to the tree. The goat is part of the Yuletide scene and getting it out of the cupboard is one of the big pre-Christmas moments. It is usually the first thing to appear when the boxes of Christmas decorations are brought out. Because of its shape, it doesn't usually fit into just one box, and so usually it just gets jammed into the cupboard with everything else.

Candles are one article that quickly goes up in smoke during Christmas, and a copious supply has to be stored. Many people even dip their own candles, a task demanding

41

both concentration and persistence, especially if you go in for the tricky business of making branched candles. In the old days, these candles would have one branch for every member of the family, and bearing in mind the size of families in those days...

Embroidered wall-hangings are another Christmas decoration in many homes. I remember my own first brave efforts, at the age of six, to produce a Santa Claus in cross-stitch. Looking at it today, I smile at the rather crooked stitches and recall what a struggle I had sewing them. It still comes out every Christmas, like another wall hanging which I won in a raffle. A friend of my mother's had made it. Every Christmas it hung over my bed and I used to study it extra carefully the night before Christmas Eve, when sleep was hard to come by. Today it hangs over my daughter's bed. She doesn't seem to be as sleepless as I

was on the night before Christmas Eve. Perhaps times have changed, or else she fools me into thinking that she has slept well, just as I used to fool my parents.

Embroidered wall-hangings aren't the only things that are put up on the walls. Paper hangings depicting Santas and elves in various guises are no less popular. And little wonder, because the motifs, not least those created by artist Jenny Nyström, exude a magical Christmas warmth that everyone is absolutely dedicated to reviving.

But vision is not the only sense to be gratified at Christmas. The season has its own particular fragrances—the food, the drink, the

candy and, of course, the flowers. Flowers play a big part in the Christmas experience, and hyacinths not least. Swedes love hyacinths. A survey ten years ago showed them topping the list of the favorite flowers for Christmas. That year 11 million were sold, and Sweden's population is just over 8 million. No wonder everything smells so nice. Often you see hyacinths in what are called "Christmas groups" –hyacinths with a carpet of moss in a beautiful pot, and of course a tiny Santa for decoration, or else a combination of hyacinths and other Christmas flowers. Poinsettia, for example–the second most popular Christmas flower,

named "Julstjärna" (Christmas Star) in Swedish.

It makes a fine red splash of color. Ideally set off in a pot from Waldemarsudde, designed by artist Prince Eugen. The azalea, the Christmas begonia and the beautiful bell-shaped amaryllis are equally indispensable. My grandmother al-ways made sure to give me one in time for Christmas Eve, a task inherited by my daughter's grandmother.

Now I usually go out and reverently choose them at Farmers Market in New York's Union Square. For without amaryllis, poinsettias and hyacinths, Christmas just wouldn't be Christmas.

Straw Craft and Christmas Goats

▸▸I wonder if there is a single Swedish home without its straw goat. For if there is any such thing as a favorite Christmas decoration, the straw goat must be it, wrapped round with red strips of cotton and with a goatee beard of rye straggling in all directions. Christmas decorations in the shape of hearts, stars and angels are also tremendously popular, not to mention door decorations of every kind. In times gone by, people didn't just make do with straw figures. Huge quantities of rye straw were brought in and almost ceremonially strewn about, turning the whole floor into a golden carpet. In addition, to the beauty it provided, this was a necessary and effective way of keeping out drafts. Houses in those days often had earth floors. The straw also made an ideal extra bed for overnight guests and a play space for the children. Virtually all mattresses in those days were stuffed with straw. To many people the fragrance of straw symbolised the greatest joy of Christmas.

Nowadays, though, people with allergies are thankful that the custom has long since died out. That happened in the 19th century, when insurance companies were formed and the fire hazard was deemed excessive. The children had a marvellous time playing in the straw, and in spare moments straw provided the raw material for all sorts of beautiful crafted objects. The best straw for working with comes from rye, and before working it you put it to soak. People once made graceful straw crowns which could be seen trembling in the not altogether draught-proof windows. But many of the things you can buy today are relatively new inventions, even though they look historic.

My grandmother always made a straw belfry at Christmas, with a tiny brittle bell of glass. I remember one Christmas, due to my playing with it carelessly, the bell shattered into a thousand pieces. Devastated, I hid the pieces away, hoping she wouldn't notice.

The straw goats, today the commonest of straw decorations, are first known from the province of Uppland. The Christmas goats which the Skansen open air museum began mass-producing in 1900 were modelled on them. Today many towns display have a huge straw goat at Christmas. The best known of them is financed every year by the shopkeepers of Gävle, a city north of Stockholm. Unfortunately it tends not to last very long, because someone always gets the idea of setting fire to it. But it's a grand sight while it lasts.

Christmas is the season of kindness to all creatures, and so even for the birds there is something in it: a beautiful "sheaf of straw", a bundle of oats tied together for them to nibble on.

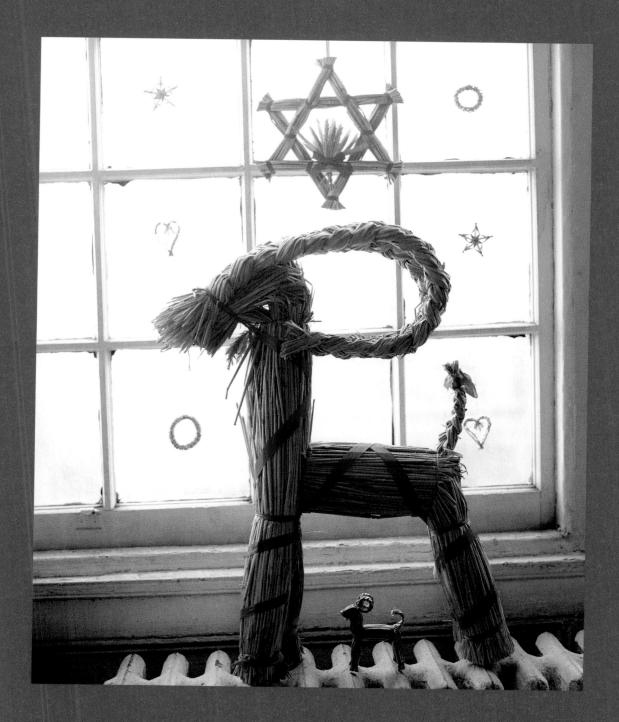

The History of Santa

He's dressed in red with a hood and a bushy beard. We all agree more or less what he looks like–Santa Claus, jultomten. But who exactly is this Swedish Santa? His pedigree, like Lucia's, isn't all that straightforward. Where does he live? Is it the North Pole, Lapland Laponia in Sweden, somewhere in Norway or Rovaniemi in Finland? This is a moot point indeed. For my own part, as a child, I was dead certain that he lived in our forest with his elf children. I even used to phone up and chat with him as a child, so that he would do an extra run on my birthday in January to dish out the bags of sweets. (I could not tell you today who was on the other end of the line.)

Yes, I knew that he was real. Never mind those dressed-up Santas as well, I knew about them too. But our Santa was real. So as an eight-year-old I just wouldn't hear of it when my father made his first hesitant efforts to inform me that there probably was no such person. There certainly was, I insisted, and as far as I was concerned, that the end of the matter for that year.

At least a couple more years were to pass before I was finally forced to come around to my father's way of thinking. But sometimes I still pretend that Santa exists. For who knows what may lie concealed behind those tussocks in the forest. Even my daughter seems to doubt his non-existence. Because nowa-

days he leaves visible traces when, on the morning of Christmas Day, he drops his sooty parcels down the chimney of our Manhattan apartment.

Who is he, then, this Swedish Santa, so beautifully depicted by artist Jenny Nyström in her many picture postcards? He is said to be a cross between St. Nicholas and the Swedish "farm-tomte", an imagined miniature essence, who used to help out on the farms in the old days. To get to the bottom of this, once and for all, we had better tell both their stories, and clear up this matter of the Swedish farm-tomte once and for all.

St. Nicholas was a Turk, at least, that's where a modern map places his native Patara, where he first saw the light of day in 270. Patara at that time was a Greek trading town. Today only ruins remain. After studying in Egypt and Palestine, Nicholas was eventually ordained a priest, becoming bishop of the city of Myra, just south of his native town, which today also remains only as ruins.

During his lifetime, and after his death, Nicholas performed many miracles, such as stilling the waves of the sea to rescue ships in distress. He soon became the patron saint of sailors, invoked by them in times of trouble and recompensed with the donation of a coin to his church in Myra. Italian merchants, realizing what a treasure Myra was sitting on,

went there to pick up the remains of St Nicholas. Despite fierce resistance by the citizens, they managed to carry off most of the relics of the saint, which were re-buried in Bari, Italy. Sailors weren't the only ones who worshipped St. Nicholas. School boys did too, in honor of his resurrection of three small boys who had been murdered and chopped up. They celebrated his death day on the 6th of December. On that day an adult had to dress up like St. Nicholas, in episcopal robes and with a long beard, and dole out presents to the pupils who had done best. The unsatisfactory students were instead given a taste of the Devil's broom, which no doubt ensured that they did better next term. Nowadays good children get presents left by Santa Claus in their stockings, a custom which has never really caught on in Sweden, although some people do put a stocking up in the fond hope of Santa finding his way to Scandinavia.

St. Nicholas caught in the Netherlands, Germany, Britain and the USA, but in Sweden, at first, he was conspicuous by his absence. Which is not to say that there were no presents. At first they were given out on Christmas Eve, and by no-one in particular. But then a generous make-believe goat with a half-moon face began knocking on the doors of cottages and handing over various gifts. That was in the 18th century,

and later he was superseded by the jultomte with his red hood, long beard, lantern in one hand and sack on his back.

There were already signs in the early Middle Ages of people believing in supernatural beings who lived on the homesteads and had to be kept sweet, otherwise anything could happen. But the Swedish "farm-tomte" didn't seem to have all that much to do with Swedish Christmas celebrations. At the same time, it was important not to forget the "farm-tomte" when Christmas was coming, a time when you had to be extra generous to people and animals and give out presents. You mustn't overdo the presents, however, because otherwise the "farm-tomte" might get lazy. The "farm-tomte" was not a congenial personality. He was rather dour and irascible, and you had to keep on his good side, otherwise he might get the idea to head out elsewhere, taking your good fortune with him. The "farm-tomte" was the one who kept an eye on the farm work, made sure that everything was neat and tidy and guaranteed prosperity. Most of his work was done invisibly, and all you could see was the results of it. Those who have seen the "farm-tomte" tell us that he was the size of a four-year-old, dressed in grey except for a red beanie, and had the face of an old man with a long white beard. He was easily annoyed and if

he was dissatisfied with the rice porridge you gave him on Christmas Eve, you would be best advised to repeat the ritual the following night and improve the quality of the porridge, for example by putting a pat of butter on top. The "farm-tomte" worked hard and took good care of the livestock. Sometimes he had his favorites, and you could tell this, for example, if a horse had braids in its mane. If you undid them, the "farm-tomte" would soon put them back again.

No one seems really to know how the Swedish jultomte evolved, but he seems in any case to be a mixture of the Swedish "farm-tomte" and his colleague St. Nicholas, alias Santa Claus. And it is through him that the Swedish Santa–jultomte–has become the annual bringer of Christmas presents. His actual appearance, calling on children in their homes, is a custom which post-dates the Christmas goat. The latter existed already in the 18th century.

Present-day children have made the goat's acquaintance through children's books by Elsa Beskow about Aunt Brown, Aunt Green and Aunt Mauve. In these books, the Santa with parcels, is replaced by a dressed-up goat.

The attractive appearance of the Swedish jultomte is mainly the creation of artist Jenny Nyström. She began drawing her many Santas at the tender age of 18, when she was commissioned to illustrate Victor Rydberg's book about Little Vigg. That was in 1875. Thereafter, her Santa motifs have been a standard feature of Christmas cards and Christmas wall-hangings.

It is fair to say that Jenny Nyström and the artist Carl Larsson between them created the Swedish Christmas atmosphere that every family works hard to achieve. In my childhood home, the Santas and elves were paraded out for all to see. Exactly how many there were I can't for the life of me say, and it's an open question whether I was able to count that far. Some were magnificent, others old and brittle and somewere my very own. Those I still have happily, I brought them along with me when I moved to the USA. Today I am glad to have them all with me. At the Swedish Church bazaar at the end of November, many of these little Santas are on sale, together with Advent candelabra and other articles associated with Christmas in Sweden.

There is really something special about getting these well-filled cartons of Christmas decorations out of the cupboard and dressing the home in the Christmas spirit. I don't know just how many Santas and elves we've got, but my husband says they are legion and could do with some thinning out. But why should I? After all, they only go on parade once in the year.

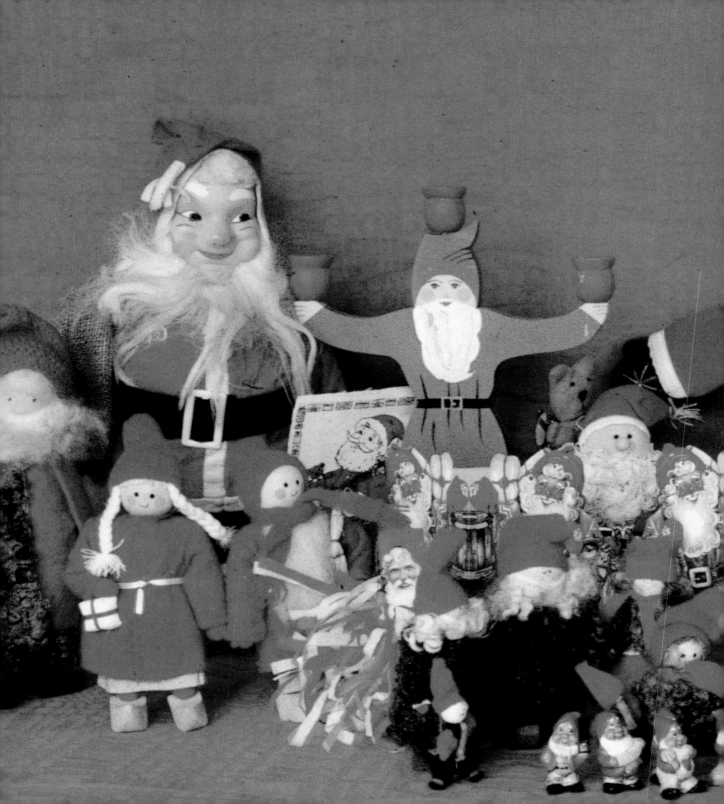

24

v 52

Eva

December

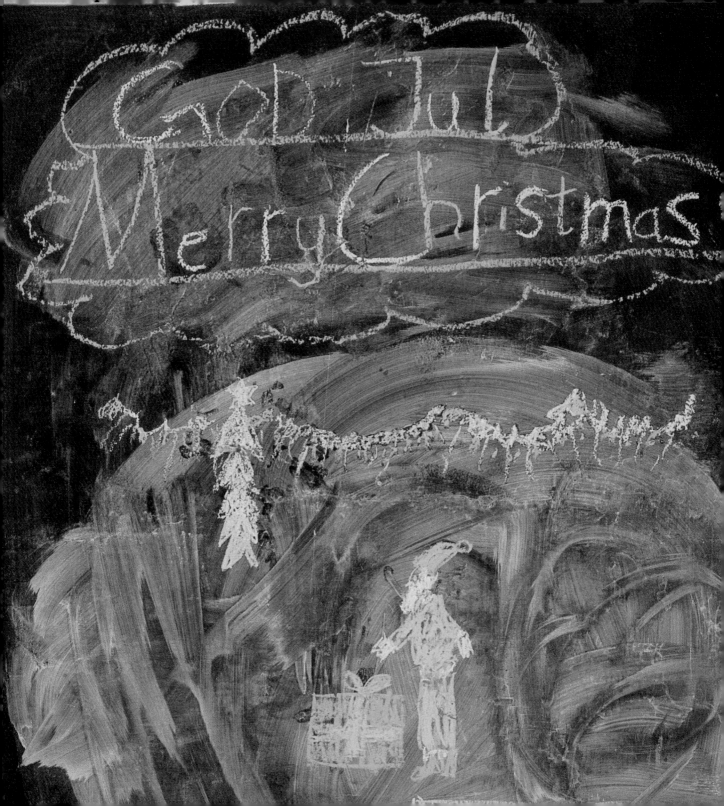

Christmas Eve

So at last it had come round, the most longed-for day of the year, Christmas Eve. It gave you a tingling feeling, when you tip-toed out of bed early in the morning, knowing that ahead of you was a long day full of enjoyable activities. Expectations ran high. Like any other child, of course, I was above all interested to know what parcels Santa would be bringing. I had a long wish list, but several hours would pass before I knew what had come of it.

The first thing we did in my home was to light a fire in the hearth and light the candles in the chandelier in the hall, the one which was otherwise hardly ever used. Then we sat down to coffee in the magical light. Mother always made a chocolate cake with lots of marzipan Santas on it. I never really liked it, but of course I didn't say so, and as an adult I can now understand that it was nerves that spoiled the taste of it for me. Lucia buns, ginger snaps and various other little cakes were also there on the big cake dish. My mother was a really keen cake-maker, known everywhere in the locality for her baking. The sparkling lights of the Christmas tree were the centre of attraction. It was always such a splendid sight. Next to it was the goat and a Santa which had been with us for many long years. Since the Christmas of my childhood,

it has gone with me even further afield, all the way to the USA, where it still has its appointed part in our Christmas celebration. In fact our Santa now has a brother which I found in a little antique shop in Stockholm.

After coffee it was time to go to Mother's Aunt Berta and thank her for the ten crowns she bestowed upon you every Christmas Eve. Even in those days it didn't seem much, but to her it probably was, because she only had a "basic pension" to live on. She had an exciting home, incredibly old. The floor creaked underfoot. The old wood stove was always burning in the kitchen. There were absolutely no modern conveniences. She lit a fire in the living room, which was otherwise cold as ice. She had a miniature Christmas tree on a table. It was a nice one. I always wondered why she had such a small Christmas tree. Great Aunt Berta had another treasure beloved of every child in the family. An angel– large, white and protectively beautiful. I could stand there looking at it for hours. "Thank's for stoping by," Great Aunt Berta would always say as we set off home through three foot-deep snow. She had an old fashioned way of saying it, unlike anyone else I knew.

Lunchtime meant the big Christmas table or dipping in the pot, just as in most other

homes all over Sweden. Everyone worked their way round the Christmas table, eating their fill and then some. We must have been a greedy bunch!

Everything had to be included, nothing must be forgotten. The Christmas table on Christmas Eve I think is as close as we Swedes ever get to the American Thanksgiving Dinner. Because on that occasion too, it's important to have all the accessories for the turkey on the table and all the family gathered round, which can mean relatives flying hither and thither all over the continent.

That is also the way with Christmas Eve in Sweden. Everyone, but everyone, has to be gathered when the Christmas table is decked, which in our case is on the dot of midday. The hosting of the table varies from one family to another. Some families always have it in the same home, year after year, while others prefer a roster of hostesses, which can be a practical idea, given all the hard work involved in masterminding the celebrations. In my case we always celebrated in the same place, at Mother's grandmother's. She was a sweet little old lady, as kind as they come, and her home was like a doll's house with creaking floors and a sparklingly beautiful Christmas tree. Before long the cottage was buzzing with life. In next to no time it filled up with 20 adults

and the same number of children. That was the tally when the eight children had had children of their own and those children had followed suit. So there wasn't much room to spare. But the atmosphere was wonderful. First we ate and ate, and while the adults completed a few more circuits of the smörgåsbord, we children had a wonderful time playing together. The differences in our ages didn't seem to matter. Everyone had the time of their life. At three o'clock everyone, adults included, sat down in a tiny little room. For the information of those who have never been in Sweden on Christmas Eve, the whole country comes to a standstill at three in the afternoon. That's when they show Donald Duck on TV, a tradition that dates back some 30 years.

Interestingly enough, the TV people tried a few years back to discontinue the broadcast, but there was such an outcry, that it never happened again. The same Disney excerpts are shown every year, accompanied by Jiminy Cricket, the Chipmunks, Cinderella, Lady and the Tramp, Santa's Workshop, Ferdinand the Bull sniffing at his cork oak, and Mickey Mouse on holiday. The only part that changes from year to year is an excerpt from the latest Disney film. At four o'clock Sweden returns to normal and the Swedish people can go on with their

66

Christmas celebrations. The importance of Donald Duck becomes apparent when you consider how people schedule their travelplans around the broadcast. Many of those who do go away phone back home at three o'clock, so as to pick up at least the dulcet tones of the television in the background. For my own part I have recorded Donald Duck so that we too can sit down at three sharp to look at it, just as we always have done. But I suppose this doesn't exactly bring the United States to a standstill.

After Donald Duck, the next visitor in many Swedish homes is Santa Claus. I remember how we used to run from window to window, looking out for him. And then finally he came into view, way up in the forest, where the branches of the fir trees were weighed down with snow. Slowly, slowly he came nearer, carrying his sack. He limped a little, in one hand he had a stick to lean on, and in the other he carried the red lantern. He knocked on the door,

opened it carefully and asked if there were any good children here, whereupon all twenty of us kids shouted at the tops of our voices that indeed there were. Santa always used to tell us that he was old, very old indeed, and wasn't up to carrying much nowadays, and so his helpers had delivered most of the parcels already. They were the ones in the boiler room. To say it was full to overflowing would be an understatement. But then there were more than 20 children's wish lists to be dealt, plus a number of parcels–far fewer, though –for the grown-ups. Santa would always check with that we'd eaten up our porridge all that past year. As luck would have it, I liked porridge and could answer that question in the affirmative. Santa read the rhymes, called the name of each recipient, and you had to walk up to him and throw a deep curtsey before he let go of the parcel. The pile of parcels grew higher and higher, but you weren't allowed to open anything until Santa had left. To raise

his strength for the long journey back home, he was given a wee drop of the hard stuff before saying goodbye and tramping off again in his clogs and red jacket.

Ripping open the parcels was the real climax of the whole Christmas. And, oddly enough, Santa had understood exactly what I wanted, even though it was to Mother I had shown the things in the toy shop. Strange. But then Christmas, to a child, was full of question marks anyway. As an adult, of course, you know the score, though you sometimes try to forget it and pretend you're a child again.

I think our Santa was rather unique, because in most Swedish homes father hardly ever sees him. Santa comes just after he's gone out to buy a packet of cigarettes or the evening paper. Strange, so many newspapers and cigarettes on sale when most shops are closed. And then there is the remarkable similarity between all these Santas. They all look just like the Santa Claus masks on sale in the Åhlén department store. The mystery remains: who was our Santa?

After the parcels had been opened, it was time to set off home. A lot of happy children–and adults too, for that matter–wended their way homewards through the wintry Christmas landscape. The snow would creak at every step. Welcoming lights would be shining in all the houses. Yes, it was a magical time, Christmas Eve.

Back home I would play with my presents. Dad used to play Christmas music, and there would be candles lit everywhere, in between the hundred or more Santa figures scattered about our home. It was so beautiful. But the finest thing of all was the Christmas tree, standing there and just looking beautiful until, a little later in the evening, we danced round it.

Christmas porridge is the next item on the programme, another tradition which nearly all Swedes have adopted. Hidden in the porridge is a blanched almond, and whoever gets it has to make up a rhyme. And not only that, but the rhymer will be married before the year is out.

Porridge isn't only for human beings. Santas and elves eat it as well, of course, and so we always put out a big bowl of the stuff. It was invariably gone the day after, and so Santa must have been there with his small helpers.

Before going to bed on this, the best day of the year, we had to do some dancing. After that you could taste a little of the fruit, the nuts and then the yummy sweets which you had helped Mother to make during the weeks of preparation.

If I had difficulty getting off to sleep on the night before Christmas Eve, no such problems assailed me on the night before Christmas Day. I was unconscious almost before my head hit the pillow.

The Swedich Christmas Smorgasbord

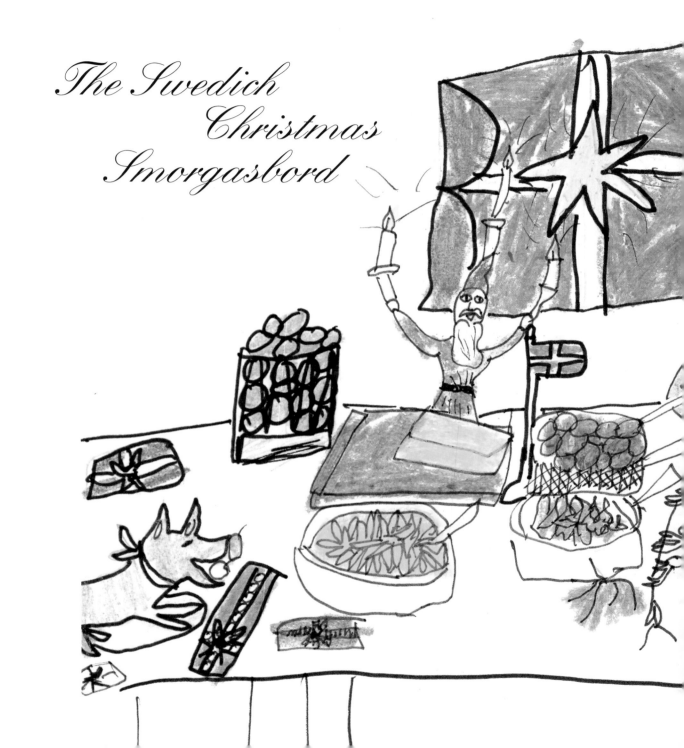

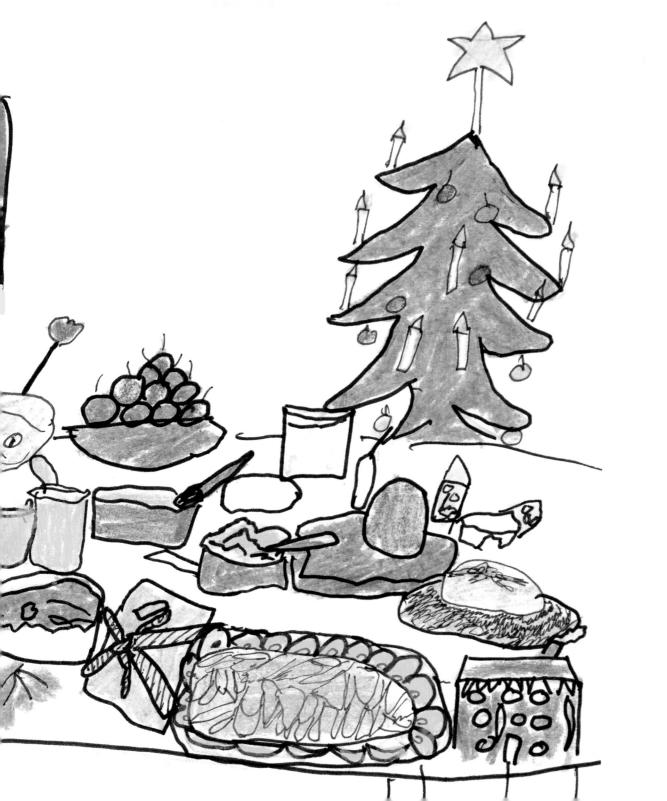

HERRING

Herring is one of the first items on your Christmas plate, and it goes down very well with a glass of Swedish vodka (schnapps). In times gone by, herring, and salt herring especially, was a staple food. Nowadays it is mainly associated with festive occasions – Christmas, Easter and Midsummer alike. It goes best with potatoes, fine-chopped red (Spanish) onion and sour cream.

Marinated Herring

16 oz herring in wine sauce
1 cup water
1/2 cup distilled vinegar
1/2 cup sugar
2 red onions
1 carrot
2 bay leaves
1 tsp allspice, crushed

- Boil the suger, water, bay leaves, crushed allspice and vinegar to make the pickling liquid. Keep on the fire until the sugar has melted.
- Remove from fire and leave to cool.
- Take out the herrings from the can and rinse thoroughly in cold running water.
- Split the red onion in two and cut the halves into semicircular slices.
- Peel and cross-cut the carrot.
- Put the herring, now rinsed and cut up, into a glass jar, alternating with layers of red onion and carrot.
- Pour on the cold pickling liquid.
- If possible, leave to stand in the fridge for a day before serving.

Herrings in Curry Sauce

1/2 cup sour cream
1/4 cup mayonnaise
1 can of Matjes herring
1 1/2 tsp. curry
Half a red paprika (sweet pepper)
1/4 cup pickled onions

- Mix the mayonnaise, sour cream, and curry together.
- Cut the paprika into small pieces.
- Pour off the liquor of the Matjes herring. Transfer the pieces of herring to a glass jar.
- Mix in the pickled onions and paprika.
- Pour on the mayonnaise mixture and blend thoroughly.
- If possible, leave to stand in the fridge for an hour or so before serving.

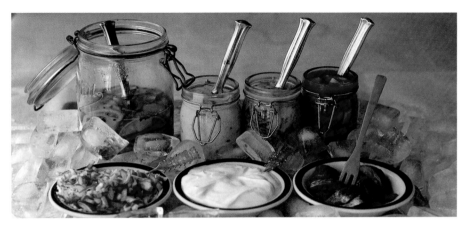

Herrings in Mustard sauce

2 tbsp mustard
2 tbsp white vinegar
4 tbsp. cooking oil
1/8 tsp. white pepper
2 tbsp. fresh-cut dill
8 oz herring in wine sauce

- Rinse the herring in cold running water.
- Transfer to a glass jar.
- Beat the mustard and oil together in a bowl. Add the dill, white pepper and vinegar.
- Pour the mixture over the herring and leave to stand in the fridge for an hour or so before serving.

Herrings in Sherry sauce

1 cup tomato juice
2 tbsp. distilled vinegar
2 tbsp. cooking oil
1/3 cup sugar
10 crushed black peppercorns
2–3 tbsp. sherry
8 oz herring in wine sauce
1 small onion

- Rinse the herring in cold running water.
- Transfer to a glass jar.
- Chop the onion small, add to the glass jar.
- Boil the tomato juice, distilled vinegar and sugar together until the sugar dissolves.
- Add the oil, sherry and crushed black peppercorns.
- Pour this mixture over the herring and if possible leave to stand in the fridge for an hour or so before serving.

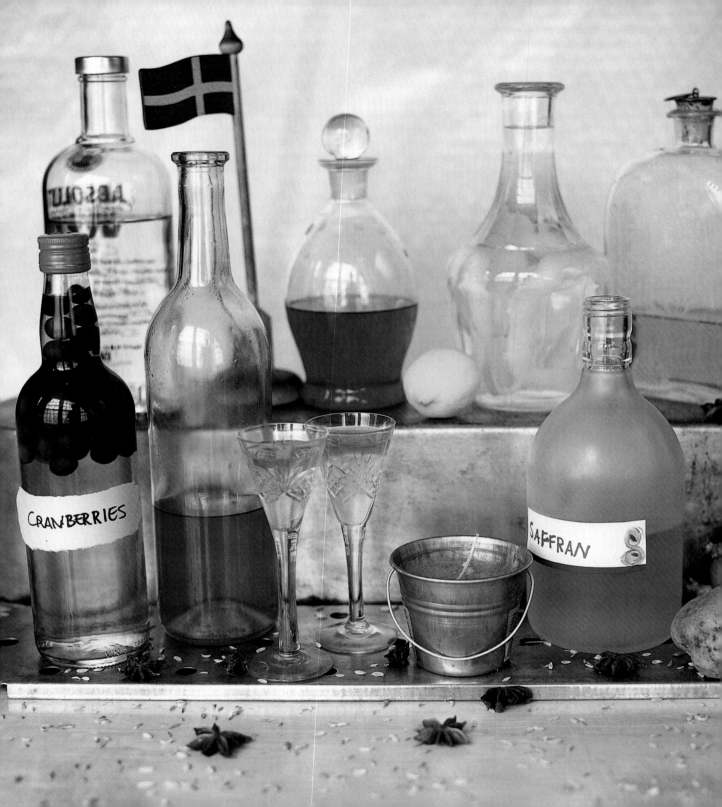

Schnapps

Swedish vodka–schnapps–has its appointed place on the Christmas smorgasbord, not least as an ongoing digestif for somewhat heavy Yuletide fare.

The best schnapps will you, of course, get if you flavor them yourself. There really isn't much to it, though the longer you can wait, the nicer the result will be.

If the schnapps is to be consumed in a Swedish maner is has to be together with a schnapps-song (snapsvisa). Swedes love to sing when they drink their schnapps. The most common one for Christmas is: "Hej tomtegubbar" (*Hi all of you santas*)

Lingonberry Schnapps

2 tbsp. lingonberry jam
24 oz vodka

- Mix the lingonberry jam with the vodka and leave to stand for a week. Strain and transfer to a new bottle.

Lemon Schnapps

1 lemon
1 bottle of vodka

- Peel a lemon with the potato peeler, taking care to avoid the pith, which has a bitter taste.
- Mix the peel with a bottle of vodka. Leave to stand for 24 hours and then strain, discarding the lemon peel.

Dill and Corinader Schnapps

1/2 cup fresh dill
1/2 tsp. whole coriander–40 corns
about half a bottle of Vodka (12 oz)

- Pound the coriander in a mortar.
- Mix the dill and the crushed coriander in a glass, pour on 4 oz cup vodka. Leave to stand for 12 hours.
- Strain through a tea strainer. Add 8 oz vodka, transfer to a bottle and leave to stand for about a week.

Aniseed, Fennel and Caraway Schnapps

1 tsp. aniseed
1 tsp. fennel
1 tsp. caraway
about half a bottle of vodka

- Put the spices in a glass, pour on 4 oz vodka and leave to stand for 12 hours.
- Strain through a tea strainer. Add 8 oz vodka, transfer to a bottle and leave to stand for about a week.

Saffron Schnapps

1 bottle of vodka
0.5 g pure saffron
1 caraway pod
1 short length of cinnamon
1 tsp. sugar

- Take about 2–3 oz of the vodka. Pour in the ingredients. Leave to stand overnight in a covered glass. Using this as your essence, add more vodka to taste.

Cranberry Schnapps

1 bottle of vodka
About 60–70 cranberries

- Put the chosen quantity of cranberries into a bottle of vodka. Steep for a week or two. No need to remove them from the bottle afterwards–they're a fine sight!

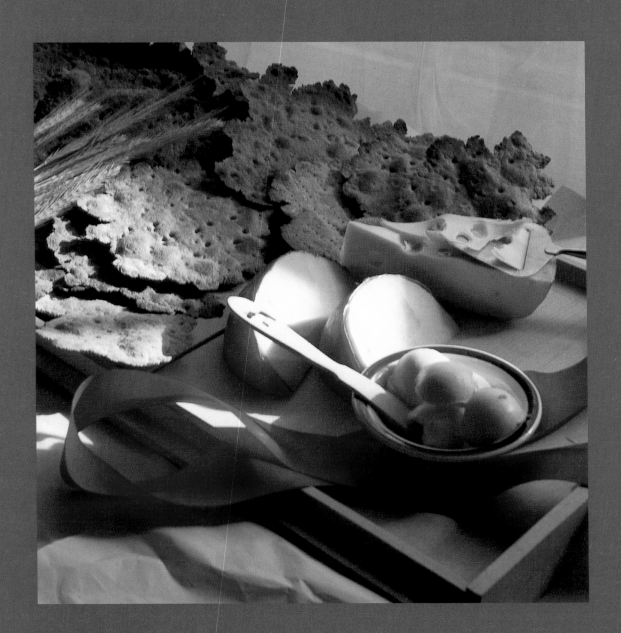

SWEDISH CRISPBREAD

The first crispbread was baked no less than 500-some years ago. It used to be made with a hole in the middle, so that it could be strung on a pole and hung up under the ceiling to dry and get extra crispy. Crispbread is tasty and good for you. And it's good workout for your teeth.

1 active dry yeast
1 1/2 cups milk
2 tsp salt
2 tsp caraway seeds
2 cups whole grain rye flour
2 cups all-purpose flour

Oven temperature:
400–440°F

- Warm the milk to 98,6°F and stir in the yeast, making sure It dissolves completely.
- Mix salt, caraway seeds, whole grain rye flour and all-purpose flour in a bowl.

- Pour the milkmixture into the bowl.
- Stir the ingredients until its no longer sticks to the bowl, form a dough.
- Knead the dough.
- Make 16 balls from the dough.
- Let them rise for 40 minutes covered by a cloth.
- Roll out the balls very thin.
- Take a fork and poke them all over.
- Bake them two and two on a greased baking tray a few minutes.

GRAVLAX

Salmon is one of the most popular party-fare fishes in Sweden, and as gravlax with salmon sauce ("head waiter sauce" in Swedish!) it's unbeatable. Not much to it, but you'll need some days for the "graving".

Middle piece from a large
fresh salmon, about 2,5 lbs
1/4 cup sugar
1/4 cup salt
2 tsp. black peppercorns
2 cups fresh dill
1/4 cup Calvados or cognac
(optional)

- Preferably, give the salmon 5 days in the freezer to kill off any parasites.
- Split down the middle, remove the backbone and try to remove all the small bones with a pair of tweezers or suchlike needle-nosed pliers. Leave the skin on.
- Crush the peppercorns in a mortar and mix them with the salt and pepper.
- Rub the filets with the mixture of salt, sugar and spices. (Calvados/brandy too, if desired.)
- Pair the filets together, meat sides inwards, with the dill in between.

- Put the salmon in a plastic bag, seal the bag and leave in the fridge for about 3–4 days.
- Turn the fish daily, and if possible put something fairly heavy on top of it.
- Pour off the liquid and scrape away the dill and surplus pepper.
- Salmon ("head waiter") sauce makes a fitting accompaniment.

Dill and Mustard sauce

Serves 4–6

1 tbsp. sugar
2 tbsp. vinegar
2 tbsp. mild mustard
finely chopped fresh dill
7 tbsp. oil
salt and white pepper

- Mix together the sugar, vinegar, mustard and dill together.
- Pour the oil slowly into the mixture, stirring thoroughly.
- Add salt and pepper to taste.

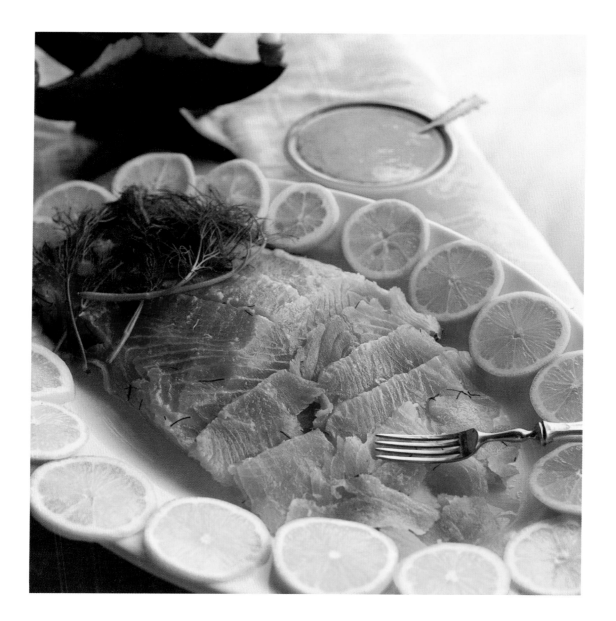

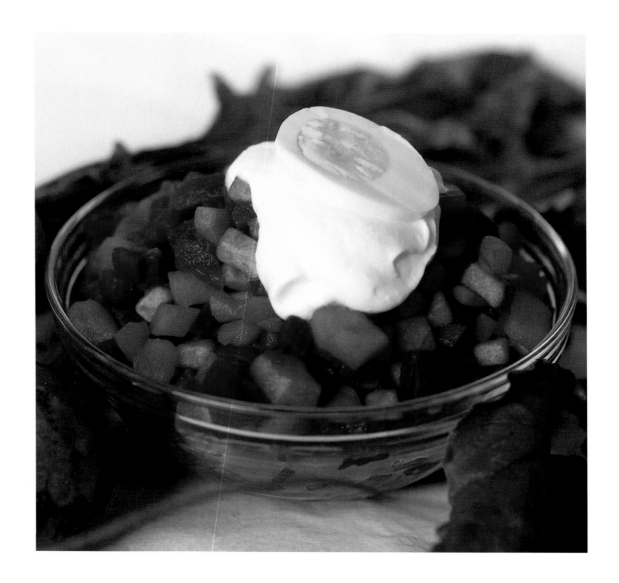

HERRING AND BEET SALAD

The ingredients for this, the main splash of color on the Christmas table, include beets, potato, pickled gherkin and apples, in addition to the herring.

1 can of red beets, 15 oz
3 pickled cucumbers/gherkins,
2–3 apples
3 1/2 oz (about 25 small pieces) herring in wine sauce
3 tbsp. sauce from the can of red beets
1 tbsp. sugar
3 boiled potatoes

Decorate with halves of hard-boiled egg and sour cream

- Peel and boil the potatoes.
- Peel and core the apples.
- Dice the beets, potatoes, herring, gherkins and apples.
- Transfer to a bowl and stir till thoroughly with your hand.
- Mix the beet liquor and sugar and pour over the salad mixture.
- Leave to stand in a cold place for half an hour.
- Decorate with sour cream and halves of egg.

SWEDISH MEATBALLS

Sweden's national dish, eaten all the year round, preferably with cream sauce, mashed potato and lingonberry jam. But at the Christmas table, you can forego the accessories, especially in the company of Jansson's temptation and spare ribs.

100 meatballs approx.

2 lb beef, ground chuck
2 normal-sized onions
1 egg
1/2 cup breadcrumbs
1/3 cup milk
1–1/2 tsp. salt
1/2 tsp. black pepper
butter or margarine for frying.

- Peel the onion and grate finely on a grater or in a food processor.
- Mix all the ingredients together in a bowl and work them thoroughly with your hands.
- Roll small, round meatballs in the palm of your hand.
- Fry them in butter or margarine in a frying pan.

GISELA'S SALMON MOUSSE

A new addition to our Christmas table, introduced as an old favorite of our friend Gisela's. A delicacy guaranteed to give you that Cordon Bleu feeling. Easy to make, but your friends will be mightily impressed.

1,5 lbs gravlax
1 lb salmon poached in court bouillon (Procedure: boil the salmon with lemon, bay leaf and onion. Bring to the boil for about 3 minutes. Leave to cool in the liquid. Strip of the flesh and transfer to a basin.)
1/2 pint heavy cream
1 lemon

- Run equal parts of the poached salmon and gravlax in a mixer to a smooth paste.
- Squeeze in lemonjuice.
- When the mixture is smooth, turn in about 1/2 pint heavy cream (not whipped).
- Line a bowl with sliced gravlax. Pour on the mousse.
- Transfer to cool and set in the fridge.
- To serve, turn the bowl upside down on a dish and turn out. Garnish with dill. For even greater effect, heat a little wine and mix with gelatin as per the instructions on the packet.
- Transfer to the fridge. When the gelatin has set, scrape it with a fork until it resembles crushed ice, then arrange it nicely round the mousse.

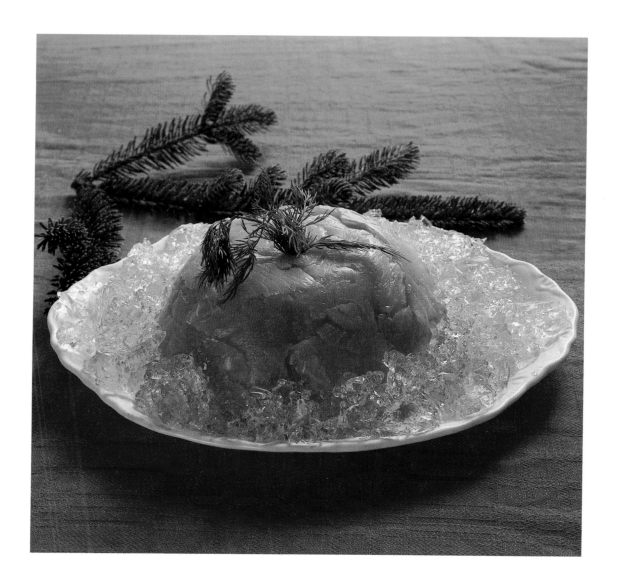

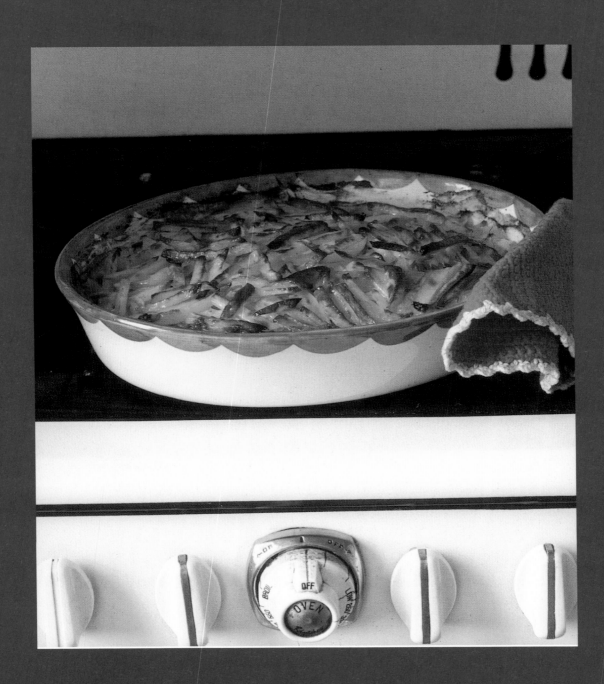

JANSSON's TEMPTATION

A sine qua non of the Christmas table and also a popular late-night snack. The origins of this national dish are a moot point, but one version tells us that it really came from the USA and is named after a Swedish preacher, Erik Jansson, who founded a religious sect at Bishop Hill, Il. Jansson preached abstinence in all things, but one day a member of the sect caught him in secretly indulging of an anchovy pudding. Jansson had met his Temptation.

8 potatoes, normal size
2 onions, normal size
1 can of anchovies in oil, 2 oz.
(If you use Swedish ansjovis, the Matjes herring can be dispensed with.)
4 oz can Matjes herring
3 tbsp. sauce from jar of Matjes herring
1 cup cream and 1/2 cup of milk, mix it
3 tbsp. butter

Oven temperature: 440°F

- Grease an oven-proof pie dish.
- Peel the potatoes and cut them into thin strips.
- Peel and cut the onion in pieces.
- Drain the anchovies. Dice them and mix with the Matjes herring, which should be diced too. Mix well with the pickling liquid from the herring.
- Put a layer of potato on the bottom of the dish, followed by layers of onion, anchovies
- Matjes herring and potato again. The topmost layer must be all potato.
- Pour half the mixture of milk and cream over the potato.
- Cover the dish with foil and place in the oven.
- After 30 minutes, pour on the rest of the milk-and-cream mixture, add a few knobs of butter to the potato and bake for another 20 minutes, with the foil removed, until the surface has browned nicely.

OVEN-BAKED OMELETTE

My oven-baked omelette has elicited more than a few raised eyebrows. "But surely," says my husband, and a few other people along him, "it has nothing to do with the Christmas table?" But it does! At least, we always had one on our Christmas table, as did my grandparents on both sides, and the neighbor, and Mom's aunties–on both sides–Dad's too, and a few more I could mention The oven-baked omelette is tasty and easy to make, and it makes an excellent companion to Jansson's temptation and meatballs.

3 egg
3 tsp. all-purpose flour
1 3/4 cups of regular milk
1/2 tsp. salt

Oven: 440°F
for about 20 minutes.

- Grease an oven-proof pie dish.
- Bring the milk to boil in a pan, then leave to cool.
- Break the eggs into a bowl. Pour on the cold milk and mix thoroughly with a fork. Stir in the flour and salt.
- Pour the mixture into the oven-proof dish and bake for about 20 minutes.
- While the omelette is in the oven, use the time for making a filling.

Omelette fillling

3 tbsp. butter
2 tbsp. all-purpose flour
1 3/4 cups of regular milk
2–3 cups mushroom,
wild if possible.
Salt and black pepper to taste.

- Wild mushrooms need to be blanched.
- Fry the mushrooms in butter in a frying pan. Add salt and pepper.
- Melt the butter in a saucepan.
- Stir in the flour and beat smooth with a whisk.
- Pour the milk on, a little at a time, letting it come slowly to the boil and thicken.
- Fold in the mushrooms.
- Pour the mixture over the omelette when itís ready.

Shrimps and canned crab are good alternatives to mushrooms for the filling.

Christmas Sausages

What would Swedish Christmas dinner be like without sausage? Not at all like Christmas dinner, many would say. Above all, there are two kinds of sausages associated with Christmas: Christmas sausage and a minisausage called "prince-sausage".

Christmas sausage is a spicier than usual form of pork sausage which every Swedish family serves on the smorgasbord. When I was a little girl we made our own sausages. I remember what a big day it was when we bought half a pig from my father's uncle and then trudged off to Aunt Mia, the family's expert sausage-maker, to study her secret recipes. She used to make the classical Christmas sausage, packed to bursting point, but my favorite was the one with pearl barley which I later learned was called Västgöta sausage (after its native Västergötland, a province in central-southern Sweden). I, of course, crave for this any time I am on Swedish soil, but I have yet to try the noble art of home sausage-making in America. Instead I rest content with going to the butcher's and buying what looks to me like Swedish pork sausage. Back home, I boil it with a few extra corns of allspice, which to me seems the most characteristic spice of the Swedish Yuletide cuisine.

The "prince-sausages" look rather like truncated hot dogs. So why not divide ordinary hot dogs into smaller pieces and pretend that they are little Swedish "princes", or else track down a German butcher, who will presumably have them in his collection?

RIBS FRIED IN ALL SPICES

Spare ribs fried crisp in allspice are a real delicacy, especially in the company of stewed apple. A sure-fire success, especially with the younger generation of revellers.

3 lb ribs, thin; it's a good idea to ask your butcher to stripes which are
3–4 inches wides.
1–2 tsp. salt
1 tbsp. allspice

- Split the meat along the bones.
- Fry the cut ribs in butter, in a covered pan.
- Crush the allspice with a pestle and mortar.
- Sprinkle with salt and the crushed allspice.
- Fry the ribs thoroughly.

LIVER PATÉ

Normally liver paté is bought ready-made, for spreading on breakfast sandwiches. Christmas, however, is the one time of year when people go to the trouble of making their own. And with a few wild mushrooms thrown in, it's well worth the effort.

1 onion
1 1/2 lb liver
1/3 cup dried mushrooms,
wild if possible
1/2 tsp. salt
1/2 tsp. white pepper
1/2 tsp. marjoram
1/2 tsp. thyme
1/3 cup all-purpose flour
1/3 cup regular milk
1/3 cup heavy cream

Oven temperature:
350–400°F

- Rinse the liver, cutting away sinews etc. Divide into pieces 1 inch cubes.
- Peel and cut up the onion.
- Chop the onion finely in a food processor. Add the pieces of liver and continue mixing until mushy.
- Cut up the mushrooms and add to the food processor together with all the spices and the flour.
- Give the mixture another short blast and then add the milk and cream, continuing until thoroughly mixed.
- Grease a large, oven-proof baking tin or two smaller ones.
- Bake for about 1 1/2 hours.

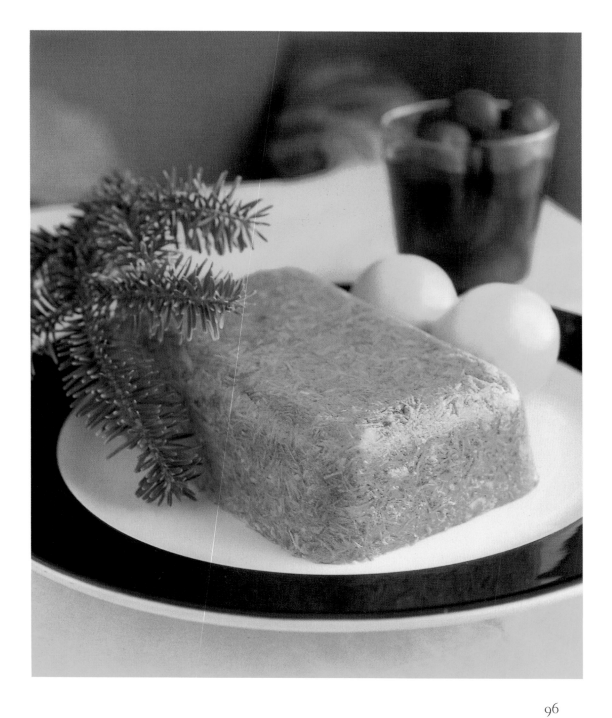

VEAL BRAWN

Veal brawn deserves to look more appetizing. But just try it! Especially with pickled beets. In days gone by it was made mostly from leftovers, but nowadays, if you're making your own, you might as well indulge in a decent cut of meat ñ preferably veal.

2 lbs of veal, or less if you buy off the bone
7 cups water
1 tbsp. salt
8 allspice corns
1 tsp. white pepper
1 bay leaf
1 large onion
2 envelopes of unflavored gelatine

- Rinse the meat before putting it in the pot with the water and bringing to the boil.
- Skim.
- Add the salt, pepper and bay leaf, and the onion–peeled and cut in pieces.
- Simmer under cover for about 1 1/2 hours, until the meat easily able to fall away from the bone.
- Remove the meat and leave to cool before cutting into tiny pieces.
- Strain the stock.
- Clean out the pot, pour the stock back in and cook on a medium flame for 25 minutes with the lid off.
- Add the finely chopped meat and the gelatine.
- Check the stock, adding a little extra salt and pepper if required.
- Pour into one or more moulds and leave to set.

Marinated Beets

2 can of sliced beets
3/4 cup water
1/2 cup sugar
3 whole cloves
1/2 tsp. white pepper
3 allspice corns
1/2 cup distilled vinegar, 5%

- Bring the water, vinegar, sugar and spices to the boil until the sugar has melted to a syrup.
- Leave to cool.
- Put the slices of red beets in a glass jar.
- Pour in the pickling liquid.
- Store in the fridge.

MUSTARD

Mustard goes with practically all Christmas food. It works wonders with Jansson's temptation and meatballs. And Christmas wouldn't be Christmas without mustard-flavored pickled herring. Finally, the aroma from a layer of mustard on your dip-in-the-pot bread over will linger pleasantly in your Christmas memories.

There are many different ways of preparing mustard, and in the south of Sweden (Skåne) they prefer a coarse-grained variety whose popularity has now spread nationwide. Adding honey for extra sweetness is a favorite addition.

1/2 cup honey
1/2 cup Colemanís mustard powder
1/2 cup heavy cream

- Stir the honey and mustard powder together until smooth.
- Add a little cream at a time, beating to a fluffy but solid consistency.
- Transfer the mustard to a screw-top jar and store in the fridge.

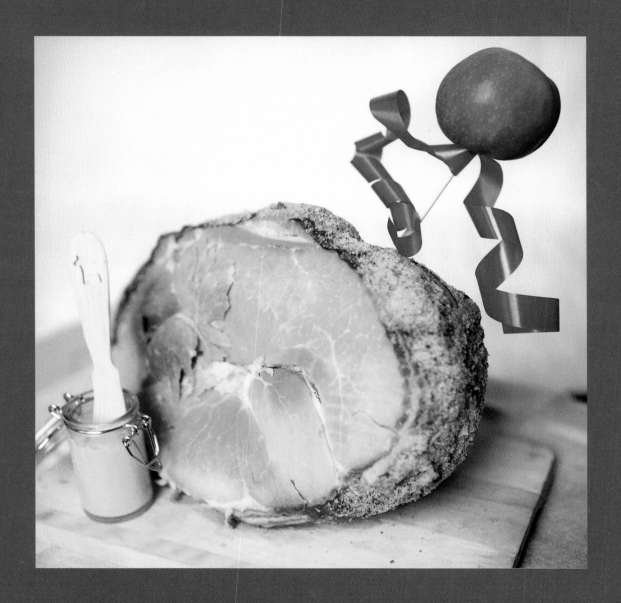

AMERICAN HAM IN SWEDISH STYLE

The ham is the centerpiece of the Swedish Christmas menu and is at its very best when eaten, straight from the grill, on crispbread with mustard.

Salting and then boiling or baking ham in an old traditional Swedish way is a job that takes several weeks and may feel like a complete waste of time. You can do just as well by shopping a ready-cooked or smoked ham and then giving it the Swedish touch under the grill. As an extra Swedish refinement, a long "ham stick", with an apple on the top, is driven into it. You can't make it more Swedish than that.

Grilling the ham

1 egg
1 tbsp. mustard
breadcrumbs

Oventemprature: 450°F

- Put the ham on a greased baking sheet.
- Beat an egg in a small bowl and stir in the mustard until dissolved.
- Brush the ham with this mixture.
- Scatter dried breadcrumbs over it.
- Bake in the oven for a few minutes, until the color is right.

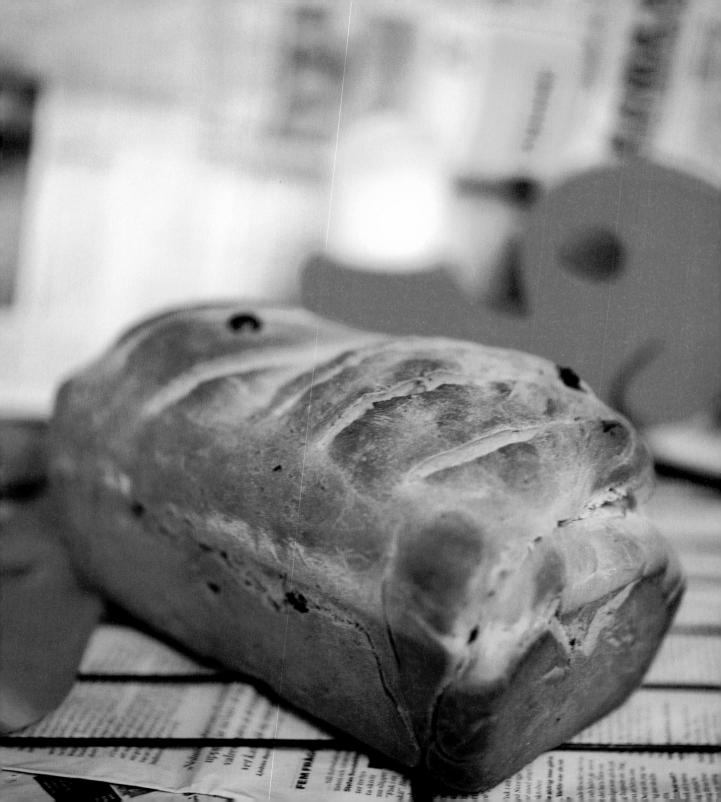

CHRISTMAS SPICED WORT BREAD

In the Christmas of olden days, people tried to give everything a festive touch. Bread was no exception, and the usual sourdough bread was now replaced by something sweeter, wort bread, the distinctive flavor of which was derived from the beer stirred into the dough. The raisins are a more recent addition. Wort bread is just the thing for the customary "dipping in the pot".

12 oz Guiness
12 oz beer
1/4 oz butter or margarine
1/2 cup corn syrup
1/2 cup honey
1 tsp. ground cloves
1 tbsp. ground ginger
1/2 tsp. salt
2 packets active dry yeast
grated peel of 1 orange
1/2 cup raisins
10–11 cups white flour

Oventemprature: 350°F

- Grate the peel of an orange.
- Melt the butter. Pour on the porter and warm to body-temprature(98,6°F).
- Stir in the yeast, making sure it dissolves completely.
- Stir in the orange peel, honey, syrup, cloves, ginger, salt and raisins.
- Add enough white flour to make a dough. Knead for 10 minutes.
- Leave to rise for 1–1 1/2 hours.
- Divide the dough and shape into two loaves.
- Place the loaves on a greased baking tray and prove for 30 minutes under a cloth.
- Bake for about an hour, until the loaves have a nice color.

"DIP IN THE POT" WITH BOILED MEAT

Originally, the custom of "Dipping in the pot" had nothing to do with Christmas. It was just an everyday method of softening stale bread scraps. Most often in Sweden, the dipping liquid is the stock from boiling the ham, but boiled beef stock will do just as well. If so, the well-cooked meat makes a tasty extra with the dipped bread, preferably with a little mustard added. A delicacy, in my opinion, but not everyone agrees.

2.5 lb beef (roast rump)
10 cups water
1/4 tsp. white pepper
12 allspice corns
3 bay leaves
1 carrot
1 tsp. salt

- Rinse the meat and boil in the water.
- Add a peeled, chopped carrot and the spices.
- Skim with a spoon.
- Boil for about 1 1/2–2 hours under cover over a low flame until the meat is tender and nearly falling to pieces.

- Divide the meat into smaller pieces.
- Strain the stock.
- Bring the stock to the boil again and reduce to a suitable flavor.
- Dip slices of bread in the hot stock. Wort bread is normally used, but any coarse bread, preferably with raisins included, will do. Spread the wet bread with mustard. Eat it with a little of the meat and, as an extra treat, a little red cabbage.

RED CABBAGE

Cabbage in many shapes and sizes forms an essential part of the Christmas table in the south of Sweden. Red cabbage, though, seems the only kind to have spread northwards. Nowadays you'll find it on most Christmas tables up and down the country. A delicacy like this also goes well with Dip in the Pot, and you get a very special aroma by taking the dip and red cabbage with a glass of cold glögg.

Serves 6–8

3 1/2 lb red cabbage
butter or margarine
1/4 cup corn syrup
3 apples
3 tbsp. red vinegar
1 tbsp. salt
1/2–1 tsp. black pepper
1/4 cup red wine or glögg

- Cut the cabbage into very fine strips.
- Melt the butter.
- Add the cabbage, alternating with syrup.
- Fry briefly, stirring all the time.
- Peel, core and cut up the apples.
- Add the apples and vinegar to the pot.
- Cook the cabbage gently, under cover, for about 40–60 minutes.
- Flavor with salt, pepper and red wine or glögg.

MUMMA

Family recipes are legion replete with all sorts of secrets about the exact ingredients and their proportions.

1 bottle of Guinness (12 oz)
1 bottle of dark beer (12 oz)
1 bottle of light beer (12 oz)
1 bottle of ginger ale (12 oz)
a pinch of ground cardamom
1/4 cup Madeira or sherry (optional)
a dash of gin (optional)

- Mix the Guinness, a dark beer, ginger ale, cardamom and Madeira or sherry (optional) in a large jug. Pour on the light beer to make a head. Lace (optional) with 1/2 oz of gin. Serve immediately.

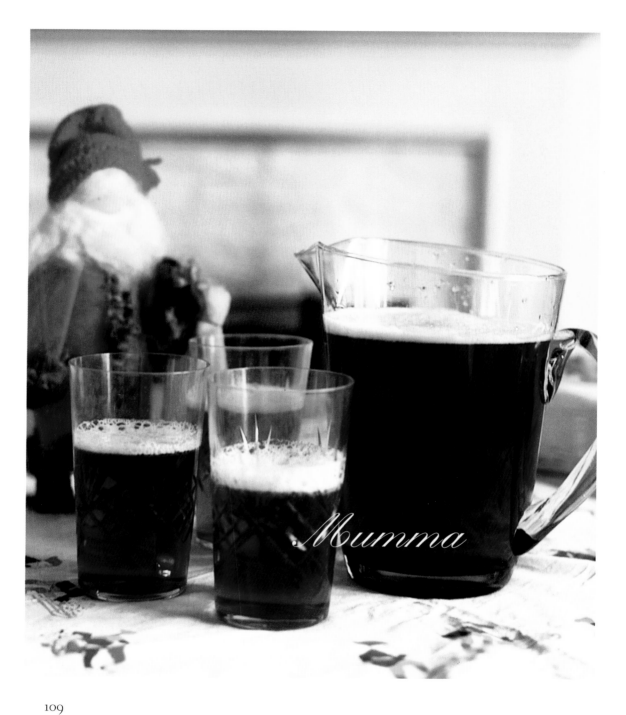

CHRISTMAS SPONGE CAKE

Sponge cake is one of the most popular cakes in Sweden, not least because it is so easy to make. A Yuletide touch can be added by baking it in a Christmassy mould.

4 eggs
1 2/3 cups sugar
3/4 cup hot water
2 tsp. vanilla extract
2 tsp. baking powder
1 2/3 cups all-purpose flour.
Berries for garnish (optional)

Oven temperature: 350°F

- Beat the eggs and sugar till fluffy.
- Heat up the water and add it together with the vanilla extract.
- Mix the powder and baking powder.
- Add everything together.
- Pour the mixture into a large greased baking tin' "Christmas-shaped" if you have one.
- Bake for 30–40 minutes.
- Garnish if possible with a few red currants or other berries, and dust with a little powdered sugar.

SANTA's RICE PORRIDGE

A blanched almond has to be concealed in the Santa's Rice porridge. That way, as the legend goes, the person who gets the almond will be married in the next year. As for now, he or she has only to improvise a short verse. During the evening a bowl of rice porridge is also put out for the house Santa, in gratitude for help received during the year

Serves 4–6

2 cups water
1 cup round grain rice, e.g. Japanese
5 cups regular milk
2–3 tbsp. margarine or butter
1 tsp. salt
3 tbsp. sugar

Serve with sugar, cinnamon and milk.

- Boil water in a heavy-bottomed pot, add the rice and salt and boil under cover until the rice has absorbed the water.
- Now pour on half the milk. Simmer over a low flame, stirring carefully after about fifteen minutes.
- Keep the porridge simmering, gradually adding the rest of the milk and stirring every now and then to keep the porridge from sticking. Mix in the butter and sugar, add salt to taste and add more sugar if required.
- After cooking for about 40 or 50 minutes, the porridge is ready to serve with cinnamon, sugar and milk.

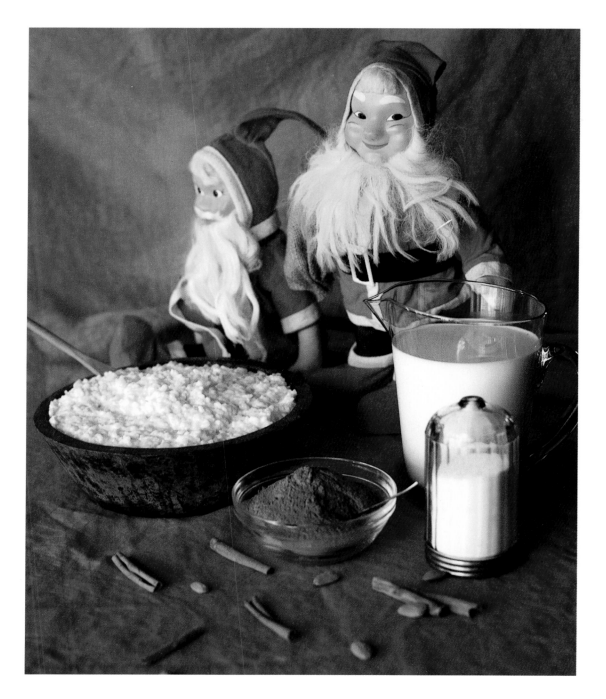

117

Christmas Day

▸▸Christmas Day begins with a church service ever so early in the morning. Swedish churches are seldom more packed than on this particular occasion. The bells ring for service at seven o'clock, sometimes even at five, and you mustn't oversleep, because in that case, so the old story has it, you might stay drowsy all the year long. But you mustn't go to church too early either, because then you might intrude on a private service held by the dead.

The churches all over Sweden are full of light at the early morning service on Christmas Day, with Christmas music and a sermon to fit the occasion. In the old days, people travelled to church by horse-drawn sleigh. From a great distance you could hear the jingle bells that had been fastened round the horses' necks. I never experienced this, but the jingle bell from my grandfather's horse is still with us. It gleams now, polished brass, in between santas and other possessions in my parents' home. Speeding along the snow-covered, slippery roads in a horse-drawn sleigh, tucked away under fleece blankets, must have been a blissful experience. The way was lit up with torches fastened to the sleigh. These were all thrown into a big blazing pile on arrival outside the church.

The journey back home turned into a horse race, as the saying went that the first one home would be the first to finish all work in the field next year. Winters were always cold in those days. Today it's practically impossible to harness the horse in the sleigh and set off. Even if there were snow, the salt and sand spread on the road would rule out any chance of gliding along on runners in the early hours of Christmas morning.

I can't claim to have attended all that many early morning services on Christmas Day. Most often I needed to catch up on all the sleep I'd missed the previous night, and to recover from all the excitement. I used to wake up to find Mom and Dad watching the early morning service on television. A good compromise with the added advantage of coffee being permitted. Christmas Day used to be a day of rest when only the really essential tasks had to be attended to. Even today it is a time for getting your breath back after one of the most arduous days of the year, Christmas Eve.

The food is usually the same as on Christmas Eve. To come in fact, our left-overs would furnish meals for several weeks. There was a time when you weren't even allowed to cook on Christmas Day.

Seven Kinds of Cookies

The Swedes are mad about "small cakes," as they call them, meaning rich, short-textured biscuits. There are seven different kinds, and at a proper coffee party you have to sample them all. For my part, I have my childhood favorites, not least among them being Granny's almond mussels with a filling of raspberries and cream. Yum, yum! But Mother's coconut pyramids were another thing you could almost gorge yourself to death on. The custom of baking "small cakes" spread through the Swedish countryside in the second half of the 19th century, following the introduction of iron stoves, which were ideal for cake-making. Previously, people had had to make do with batter cakes like fried crullers (imperial crowns or rosettes) and Christmas crullers (fried twists). These again are typical Christmas pastries, but Christmas crullers in particular require special tools that are not easily found in America, and so I have kept to easier delicacies. Try the gingerbread spice cake, which contains the same spices as the gingersnaps and, if anything, is even tastier. Here again, the old family recipes have come into their own. So why not indulge in a whole afternoon of Swedish baking and then sit back to enjoy the results with a cup of good coffee? In times gone by, people used to drink their coffee from the saucer, often with a lump of sugar in their mouths. My grandfather always did, I remember, and so did his brother. Presumably the Swedes took the habit with them to the United States, but then it was forgotten in both countries. Getting out the best china and drinking one's coffee from a cup with something nice to go with it is certainly a more delectable arrangement.

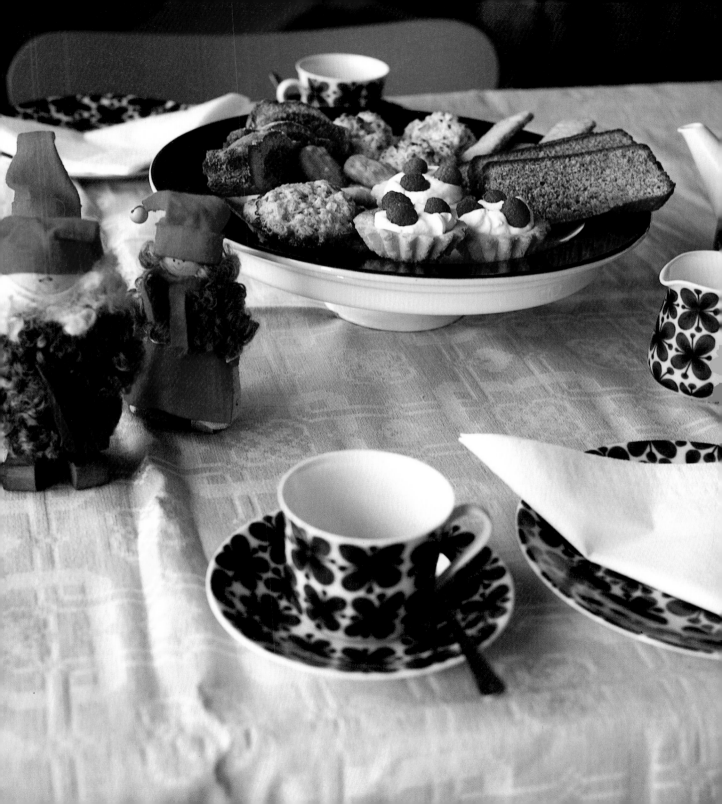

Grandma Ediths's Almond Mussels

2 1/2 cups all-purpose flour
9 oz butter, room temperature
7 tbsp. sugar
1/2 cup almonds, blanched
and ground

Whipped cream and berries
(raspberries preferably) as a
filling, to add just before
serving.

Oven temperature: 400°F.

- Grind the almonds or chop
 them finely in a food processor.
- Mix the sugar and butter
 together.
- Add almonds and flour to make
 the dough.
- Grease the moulds carefully
 with butter.

- Line the moulds with pastry.
- Bake for 5–10 minutes until
 slightly golden.
- Let the moulds cool a little
 before carefully tipping out the
 almond mussels–carefully,
 because they break easily.

Oatmeal Snaps

Makes 25–30

1 cup oatmeal
3/4 cup sugar
1 tbsp. corn syrup
2 oz margarine or butter
2 tsp. heavy cream
1/2 cup all-purpose flour
1/2 tsp. baking powder

Oven temperature:
350–400°F.

- Melt the butter and stir in the
 cream, sugar and syrup.
- Mix the oatmeal, flour and bak-
 ing powder in a bowl. Pour on
 the butter mixture.
- Grease a baking tray.
- Distribute small knobs of the
 mixture, not too close together.
 Flatten them slightly and then
 bake for 5–10 minutes. Option
 ally, while they are still warm
 you can bend them a little to
 improve the shape. Or else you
 can sandwich them in pairs
 with a little chocolate cream in
 the middle.

Ediths's Mussels

Oatmeal

Mother's Coconut Tops

Makes 25–30
1 cup oatmeal
3/4 cup sugar
1 tbsp. corn syrup
2 oz margarine or butter
2 tsp. heavy cream
1/2 cup all-purpose flour
1/2 tsp. baking powder

Oven temperature: 350-400°F.

- Melt the butter and stir in the cream, sugar and syrup.
- Mix the oatmeal, flour and baking powder in a bowl. Pour on the butter mixture.
- Grease a baking tray.
- Distribute small knobs of the mixture, not too close together.
- Flatten them slightly and then bake for 5–10 minutes. Optionally, while they are still warm you can bend them a little to improve the shape. Or else you can sandwich them in pairs with a little chocolate cream in the middle.

Märta's Toffee Cakes

4 oz butter
1 1/4 cups sugar
1 1/2 cups all-purpose flour
1 egg yolk
1 tsp ground cardamom
1 tsp baking soda
1 tsp corn syrup
1 tsp vanilla extract

Oven temperature:350–400°F

- Mix all the ingredients together.
- Roll into cylindrical strips.
- Put these on a baking tray and flatten slightly.
- Bake for about 10 minutes until they are a nice color.
- Cut diagonally into pieces measuring about 1 inch.

Country Cakes

3/4 cup sugar
1 cup all-purpose flour
5 oz butter
1 tsp. baking soda
1 tbsp. corn syrup
1/4 cup almonds, blanched and chopped fine

Oven temperature:
350–400°F

- Blanche the almonds and either chop them all finely or chop half and put the other half through the grinder.
- Cream the butter and sugar.
- Add the syrup.
- Fold in the almonds.
- Mix the baking soda and flour in a separate bowl.
- Add the flour and baking soda mixture to the other ingredients and work together into a dough.
- Roll the dough into strips. Be patient! Sometimes it breaks up, in which case you just have to roll it again from scratch.

- If possible, put the strips in the fridge for half an hour.
- Cut the strips into 1/2 inch slices with a sharp knife. Transfer to a greased baking tray for baking.
- Bake for about 5–10 minutes.

Grandma Mia's Tiger Cake

2 eggs
1 cup sugar
3 1/2 oz butter
3/4 cup heavy cream
1 tsp. baking powder
1 cup all-purpose flour
1 tbsp. cocoa

Oven temperature: 350°F

- Melt the butter.
- Beat the eggs and sugar until fluffy.
- Add the melted butter, together with the cream.
- Mix the baking powder and flour in a bowl.
- Add this to the mixture.
- Pour 1/3 of the batter into a separate bowl and stir in the cocoa until the batter "turns chocolate".
- Pour half of the "white batter" into a greased baking tin. Now add the "chocolate batter" and then finish off with the rest of the "white batter". Carefully stir with a fork, to make sure the two sets of batter in the tin mix properly.

- Bake for about 45 minutes, until the cake is a nice shape. Test with a tooth pick, if it comes out without cake on it the the cake is done.

GINGER SPICED SPONGE CAKE

Ginger spiced sponge cake offers the same kind of gastronomic sensation as gingersnaps–both include the same spices. This particular recipe has been handed down from generation to generation.

2 eggs
1 cup sugar
4 oz margarine or butter
1/2 cup sour cream
1 1/4 cups all-purpose flour
1 tsp. baking soda
1 1/2 tsp. ground ginger
1 1/2 tsp. ground cloves
2 tsp. cinnamon.

Oven temperature: 350°F

- Melt the butter and leave to cool.
- Beat the sugar and eggs fluffy.
- Add the sour cream, butter and spices.
- Mix the flour and baking soda thoroughly in a separate bowl, then fold into the first mixture.
- Grease a baking tin.
- Bake for about 45 minutes.

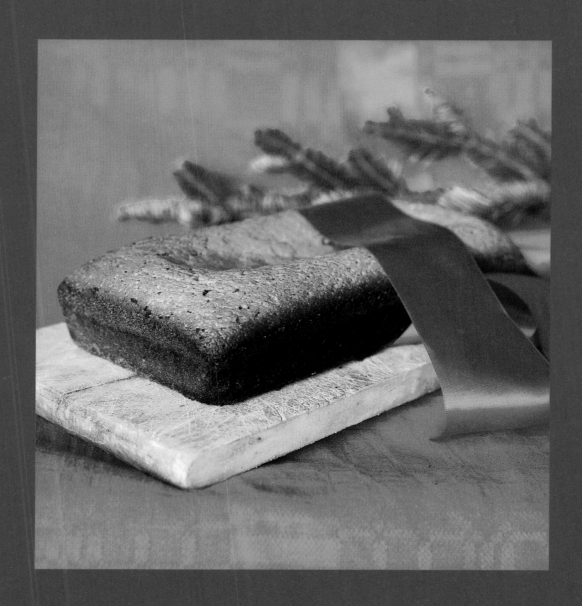

Boxing Day

▶ If Christmas Day used to be a day of rest, Boxing Day was just the opposite, especially among the farmhands, who got up to all kinds of mischief. On the morning of Boxing Day the horses had to be given their ritual water, which according to myth, would keep them healthy all the following year. Their water must be taken from a stream flowing northwards. This is mentioned in a favorite song, "Staffan was a Stable Boy." which all Swedish schoolchildren have to learn even though heart, few people know what the song is really about.

The Staffan Ride was another Boxing Day occupation, a horse race full of magic. Here again, things could get rather out of hand, if one or two people drank too much at the party which followed. From my own childhood I remember the big Christmas parties that used to take place on Boxing Day. A lot of the relatives who had got together on Christmas Eve would then be reunited at the home of some other member of the clan. Once again they would eat and eat. When I was small, most things were closed on Boxing Day. Nowadays all the shops are open and you have the obligatory Boxing Day Sale when all the expensive presents you bought are sold off at half price. People out to swap Christmas presents collide with Boxing Day bargain-hunters, and the streets are crowded to say the least.

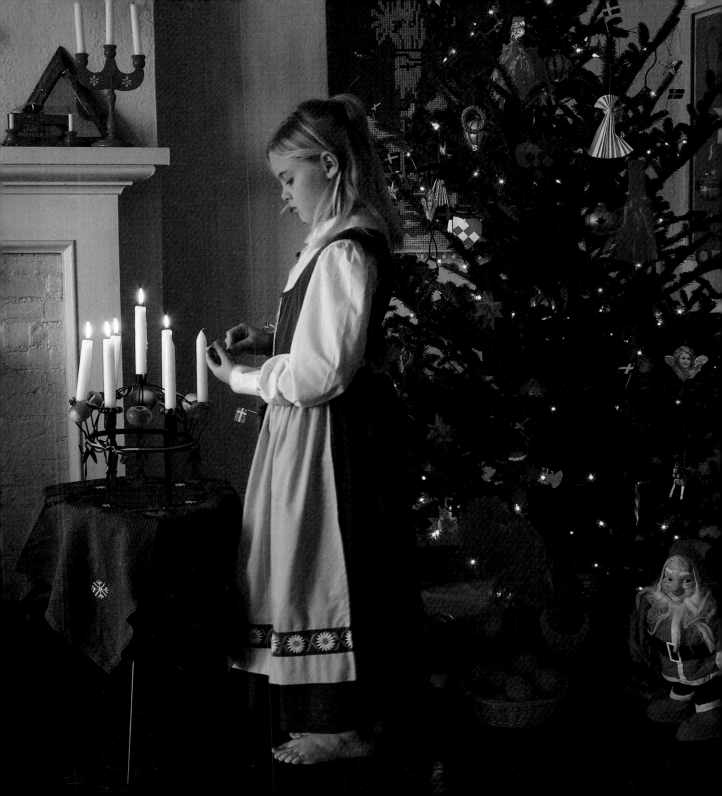

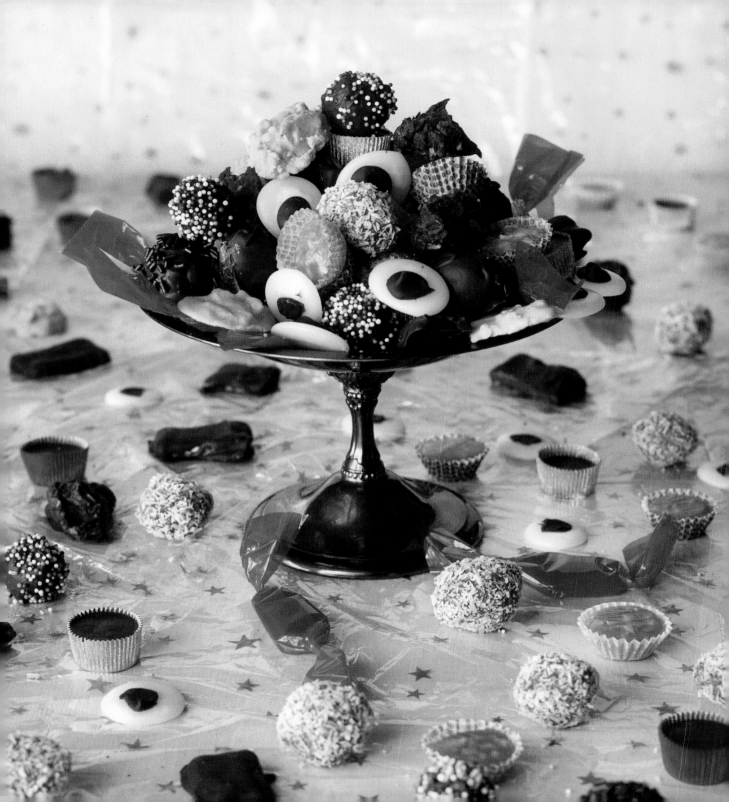

Christmas Candies

Of all the preparations for my childhoods Christmases, making Christmas candies was one of the most enjoyable. Although we were told you mustnít eat any until Santa had arrived, we could at least lick the bowls clean as a preview to the delights to come. And occasionally, sometimes we even, no doubt, we raided the larder in the cellar, where the specially-lidded candy containers were neatly lined up. How we longly lifted those lids. I guess the rule of pre-Christmas abstinence was a little more honored in the breach than in the observance.

Brandy Balls

1/2 lb almond paste
4 figs
2 tsp. brandy
6 oz baking chocolate bars

- Cut the figs into very tiny pieces.
- Pour the brandy over the almond paste and work into a dough. Add the pieces of fig and work them in as well.
- Roll little balls.
- Melt the chocolate in the microwave or into a bowl over a pan of barely simmering water.
- Dip the balls in chocolate and put them on greaseproof paper to set.
- Putting them in the fridge for a while is a good idea.
- Remove them carefully from the greaseproof paper, using a sharp knife if you want the brandy balls to keep shape.

Toffee–Knäck

Makes 80–100

11/4 cups sugar
11/4 cups corn syrup
11/4 cups heavy cream
21/2 oz almonds

- Blanche and chop the almonds.
- Mix the sugar, syrup and cream in a heavy-bottomed pan, bring to boil.
- Continue cooking on a medium flame.
- Use the "ball test" 250–260°F) to check if the toffee is ready. Collect a little on a spoon, cool it in running cold water, and then try rolling it into a ball. If you succeed, the toffee's ready.
- Add the chopped almonds.
- Drop the hot, sticky toffee mixture into small paper cases. Be careful. Toffee burns can be really nasty. And toffee-making of any kind is something that children are best kept out of.
- Toffee also needs to be eaten with care. It can be harder than you think, and you might run up quite a dentist's bill.

Dajm–Toffee Squares

Makes about 40

6 tbsp. butter or margarine
11/4 cups sugar
4 tbsp. regular milk
2 tsp cocoa
2 oz almonds,
chopped very fine
4 tbsp. corn syrup
8–10 oz baking chocolate bars

- Melt the butter in a heavy-bottomed pan, then add the cocoa, milk and syrup.
- Boil for about 5 minutes, stirring all the while, after the mixture

Brandy balls

Dajm-Toffee

Caramels

Toffee-Knäck

has solidified a little. Pour the mixture–taking care not to burn yourself–onto a grease-proof paper.

- Cut in pieces before it has set completely.
- Melt the chocolate, either in the microwave or into a bowl over a pan of barely simmering water.
- When the toffee is quite cold, dip the pieces in chocolate and put them on greaseproof paper to set. A brief spell in the fridge will do them good. Eat them with care – here again a dental hazard warning is called for.

Chocolate Caramels

Makes about 50

1 1/4 cups heavy cream
2 oz butter
1 1/4 cups sugar
3/4 cup corn syrup
1/4 cup cocoa (optional)

- Mix all the ingredients together in a heavy-bottomed pan, bring-ing them to a boil so as to melt the butter. For chocolate toffee, add 1/4 cup cocoa.
- Continue cooking on a medium flame.
- Cook for about 20 minutes, stirring occasionally.

- Run the ball test; see the Dajm-Toffee Squares recipe.
- Pour the mixture onto an oiled baking tray. Carefully not to burn yourself.
- Leave to cool and then mark squares with a sharp knife. Cut them out later. When they are quite cold, wrap them in appropriately sized cellophane paper which you twist at each end.
- A real treat, but here again, a dental hazard warning is called for.

Mint Kisses

Makes about 50

4 cups powder sugar
1 cup water
1/2 tsp. distilled vinegar
8 drops peppermint
3 1/2 oz baking chocolate bars

- Boil the sugar, water and distilled vinegar in a heavy-bottomed pan for about 10 minutes or until the mixture passes the thread test (239°F), which involves carefully pouring a little cold water onto a few drops of it. If the mixture forms threads, itís ready.
- Pour the mixture into a bowl and after it has cooled down a little bit, add the peppermint oil, stirring until the mixture is even and fairly viscous.
- Distribute large blobs of the mixture–coin-sized–onto grease-proof paper and leave to set.
- Melt the chocolate in the microwave or into a bowl over a pan of barely simmering water, placing small blobs of it on each of the mint kisses.

Grandma's Pink Caramels

Makes about 40

1 1/2 cups sugar
3 oz butter
1 1/4 cups heavy cream
1/2 cups almonds, blanched and chopped
3–4 drops red food coloring

- Blanche and chop the almonds.
- Mix all the ingredients except the almonds in a heavy-bottomed pan and color the mixture pink with a few drops of the red food coloring.
- Cook slowly, stirring all the time.
- Try dipping a little of the mixture on a spoon in cold water. When the hardness is right, remove from the heat and add the chopped almonds.
- Leave to cool.
- Distribute small blobs on greaseproof paper and leave until cold.

138

Mint Kisses

Chocolate with coconut

Ice Chocolate

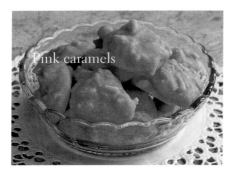
Pink caramels

Ice Chocolate

Makes about 30

4 oz chocolate
4 oz butter
Orange juice or sprinkles
as flavoring. (optional)

- Melt the chocolate in the microwave or into a bowl over a pan of barely simmering water.
- Melt the butter in a saucepan.
- Mix the butter and chocolate together and pour into a jug with a narrow spout.
- Add the drops of pressed orange juice. (optional)
- Pour the mixture into small aluminium moulds.
- To make the ice chocolate a little crunchier, you can put sprinkles in the moulds before you pour chocolate in.
- Put the moulds in the fridge until cold.
- Store cold if possible.

Chocolate with Coconut

Makes about 20

3 1/2 oz butter or margarine
1 tbsp. cocoa
4 tbsp. sugar
1 1/4 cups oatmeal
1 tbsp. water
coconut for decoration

- Mix all the ingredients together.
- Shape little balls.
- Roll them in coconut.

New Year

▸ If Christmas now is the big day of the year for giving, New Year was its counterpart in the past. That was when the girl had to give her fiancé something beautiful she had made herself. Not stockings, though, because that meant an unhappy marriage. The man too must give his girl something made with his own hands.

New Year was also the day for fortune telling, using lead or tin. The metal was melted and then poured into a bucket of water to set. Its appearance would tell you what to expect of the coming year. If the metal was smooth and shiny, you could expect to stay healthy all the year long, while on the other hand if it had a rough surface the health outlook wasn't so good. If the metal assumed the shape of a cross, that was really bad, portending serious illness or death. If it looked like a crown that was a good deal more gratifying, because it meant marriage.

You must not lend money to anyone on New Year's Eve, because that would mean your purse would be open all the year round, perhaps with disastrous financial consequences to yourself. You also had to take care not to be cross and grumpy, angry or sleepy, because the saying went that as your humor was at the New Year, so it would remain until the year was out.

New Year's celebrations in Sweden today aren't much different from the rest of the world. At the stroke of midnight, rockets go shrieking and whizzing over the smallest towns and villages, to a popping of champagne corks in castle and cottage, for this is festival time and the New Year must be properly toasted. The menu often includes lobster and other shellfish. Everything in the way of Christmas fare sat aside. Now it's a party menu that's called for, and, months in advance, magazines are full of hints on how to make a success of that New Year dinner. If Christmas is dedicated to the family, New Year's Eve is all the more dedicated to friendship. But even then there is no getting away from the television. For just as Christmas Eve has its Donald Duck, so New Year's Eve has its own television phenomenon, shown year after year: "The Countess and the Butler"–an English sketch about an inebriated servant who has to act the parts of a number of guests drinking to the health of his countess. Nobody seems to know or understand quite why this black and white sketch has become such a hit.

Every New Year's Eve at Skansen, open-air museum in the centre of Stockholm, the stroke of midnight is accompanied by a reading of Tennyson's poem "Ring Out, Wild Bells". The proceedings can also be watched on television. The latest actor in succession to be given the honor of reading the poem is Jan Malmsjö, and all his predecessors have been great men and women of the theatre. "Ring Out, Wild Bells!" the words echo forth, as all the church bells of Stockholm ring in the New Year and the sky above is criss-crossed with rockets.

"Twentieth Day Knut"

▶▶ Yes, I guess you could say numbers pop up a lot in the Swedish Christmas season. Twelfth Night, is of course, January 6, the evening before Epiphany when according to the Bible, the Christ Child was visited by the Three Wise Men. In more recent times, it seems that many people have forgotten the religious side of Christmas, and Twelfth Night–notwithstanding Shakespeare's glorious play ñ is just an excuse for taking some time off from work. Twentieth Day Knut, on the other hand, has more specific Christmas rituals attached to it. It falls on January 13. Knut is the name of the day and, by tradition, it is the day when Christmas officially "dances out". The Christmas tree, of course, plays a crucial role in all of this, and hopefully, it is still in reasonbly good condition, though there is hardly any guarantee of that. When I was growing up, our tree was sometimes in such sorry shape by the time January 13th rolled around that it had already been removed from the house, leaving behind a mere dusting of pine needles. Twentieth Day Knut is also the day we "plunder" (Julgransplundring) what's left of the Christmas tree. In my childhood this meant that at long last you had to eat up the chocolate pine cones dangling around the tree, though I must admit it could feel a little strange singing "Christmas is here again" just when the festive holiday season was about to draw to a close. But we did it anyway. And so what if the tree looked a litte under the weather by this late date? Alas the only thing still to do after was to throw out the poor thing. That was sad, as all good-byes are sad ñ it meant that Christmas was officially over. But there was always this one recompense: Only eleven months to go til the next Christmas came knocking at the door.

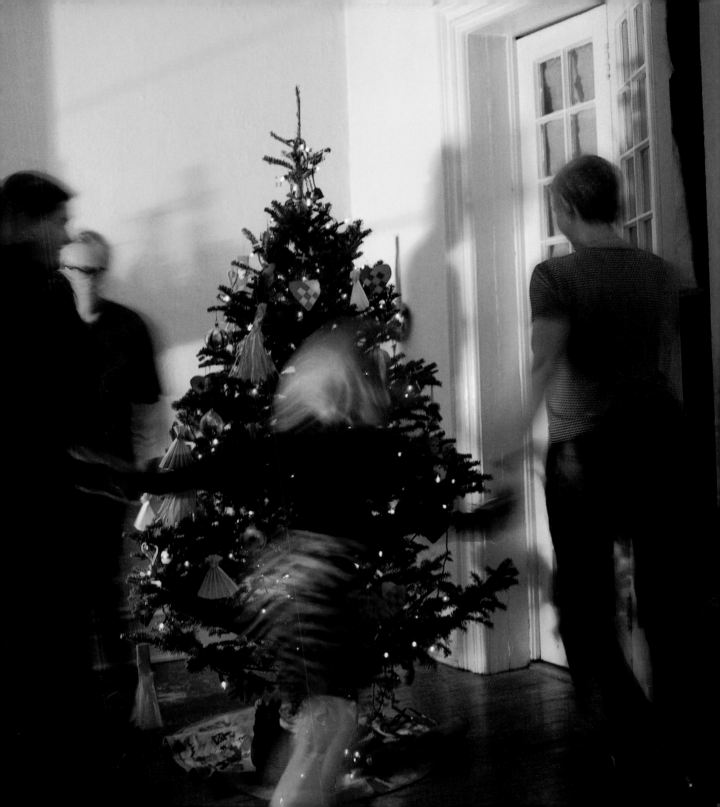

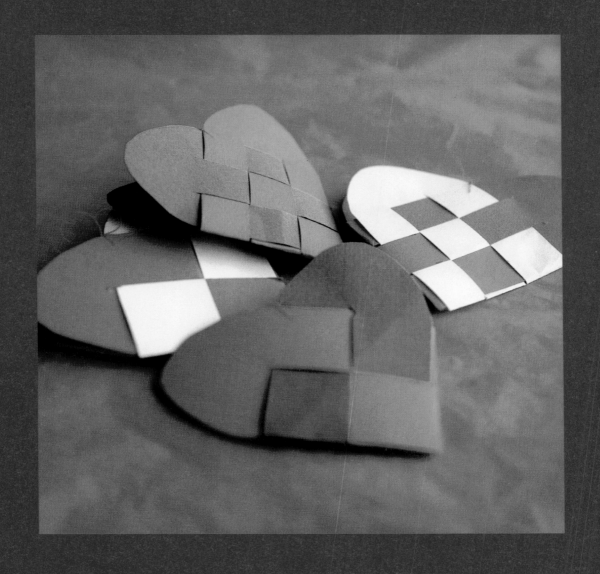

Directions of how to make the Christmas Ornaments

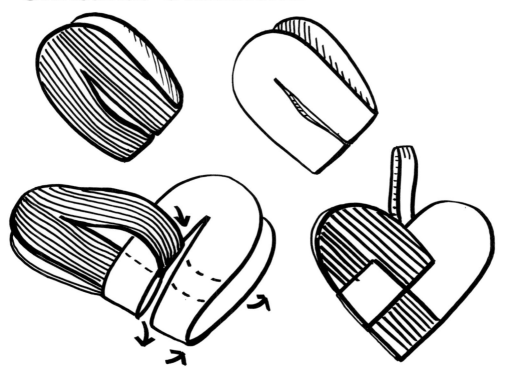

BRAIDED HEARTS

- Start by drawing a "half-heart" template of the size preferred. Fold two differently colored sheets of paper in half. Place the template on the fold paper, draw and cut out. Then cut once or more over the folded edge, depending on the type of braiding required. Suggestion: cut just once to begin with, until you have mastered the technique of braiding.
- Braid the heart together by inserting the white flap into the colored one, threading the next flap into the white one, then braiding in the colored flap, and so on. Putting it simply, what you do is to put the flaps alternately through and round the folded half-hearts.
- Glue on a handle to hang up the heart basket.

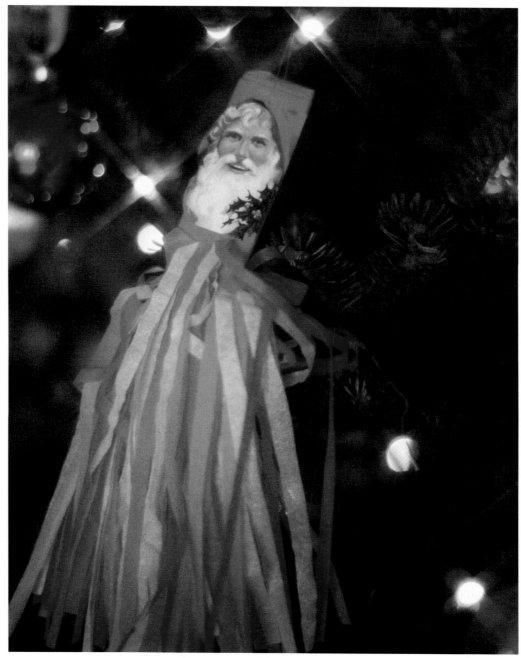

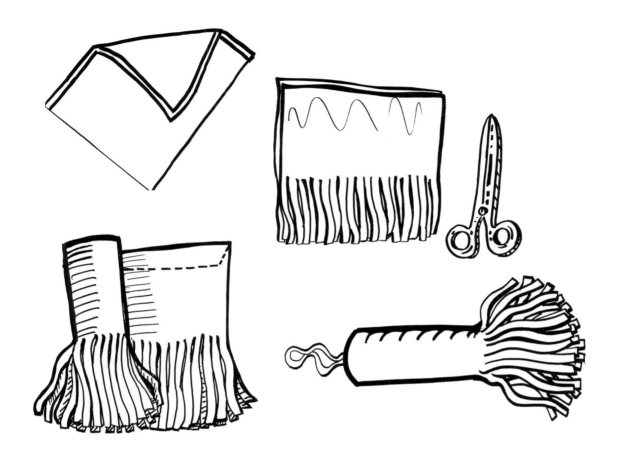

CHRISTMAS CRACKER

- Take at least two differently colored sheets of tissue paper, measuring about 16 × 16 inches, and place them one on top of the other.
- Cut strips about 8 inches long and 1/4 inch wide along both sides, cutting from the edge towards the middle.
- Fold in a margin of the uncut side and glue it.
- Fold a margin of about 1 inch on the cut side and roll the tissue paper over it. Finish off with a slick of glue.
- Give the cracker a shake, to mix up the cut-out strips. Decorate (optional) with a bookmark or by sticking on gold paper. Sew on a thre to hang the cracker up by.

147

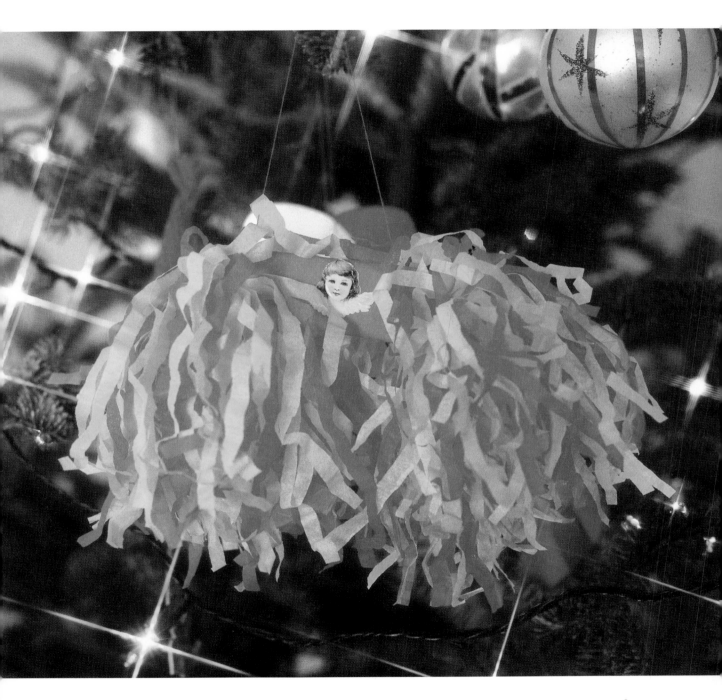

148

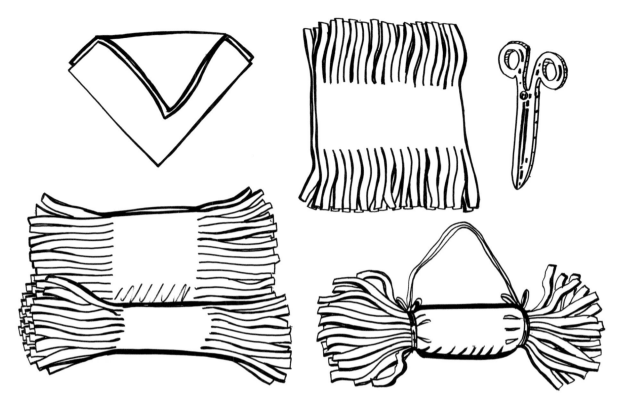

CHRISTMAS CRACKER–
DOUBLE VERSION

- Take at least two differently colored sheets of tissue paper, measuring about 18×18 inches, and place them one on top of the other.
- Cut strips about 6 inches long and 1/4 inches wide along both sides, cutting from the edge towards the middle. To make the crackers more crinkly, fold the paper before cutting.
- Tuck in a margin of about 1 1/4 inches, or else roll up the tissue paper. Make sure the strips protrude from the latter. Finish off with a slick of glue where the paper ends.
- Tie a ribbon round one end and across to the other, to hang the cracker up with. Secure the ribbons. Decorate (optional) with a bookmark or by sticking on gold paper. Give the cracker a shake, to mix up the cut-out strips. Hang them up.

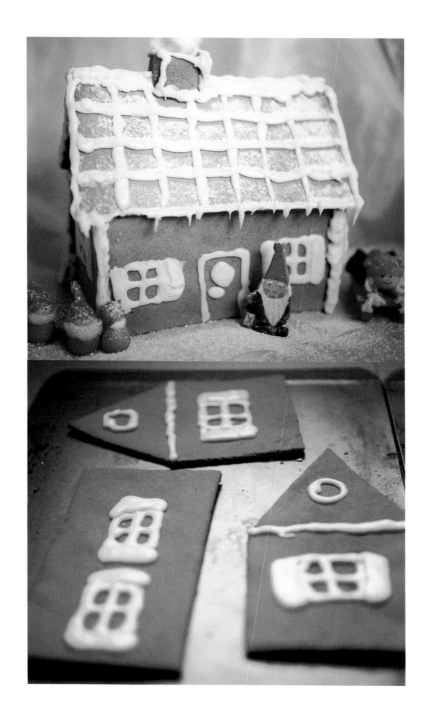

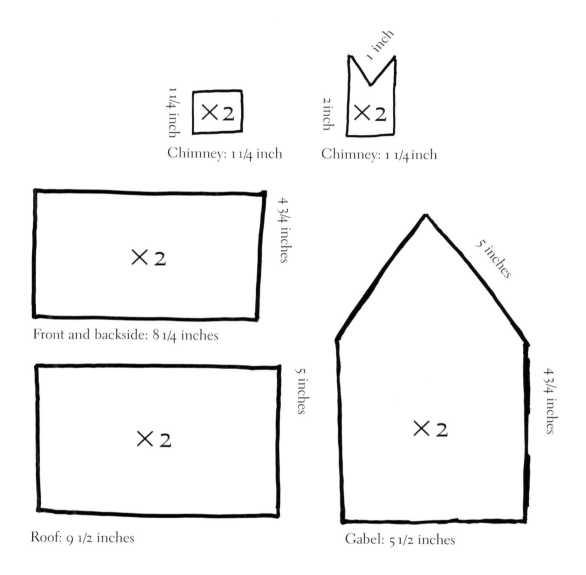

Chimney: 1 1/4 inch

Chimney: 1 1/4 inch

Front and backside: 8 1/4 inches

Roof: 9 1/2 inches

Gabel: 5 1/2 inches

Measurments for Gingerbread House from page 26–27

THANKS to Emilie, for patiently serving as a model, for drawing and for enduring Christmas food all the year round for two whole years.

Anders Ekberg, for having faith in our idea.

Gisela Nilsson, for being our mainstay throughout our protracted project, as an unflagging listener and participant, whether tasting the Christmas fare or charing us her own recipes.

Stan Schwartz, Peter Pearth, Peter Firestein and Sheree Stomberg for charing us your languageskills. Olle Wästberg and Inger Claesson Wästberg for opening doors and giving us connections through America.

All the friends who have graced our Christmas dinners with their presence over the years. Without your enthusiasm and curiosity about the Swedish Christmas cuisine, Swedish Christmas would never have materialised.

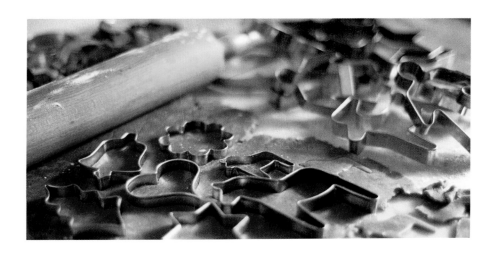

MEASURMENT AND CONVERSIONS

Conversions of US Liquid
measures to nearest metric:

1/2 tsp	= 2.5 ml
1 tsp	= 5 ml
1/2 tbsp	= 7.5 ml
1 tbsp	= 15 ml
1/4 cup	= 2 fluid oz
	= 60 ml
1/3 cup	= 2/6 fluid oz
	= 80 ml
1/2 cup	= 4 fluid oz
	= 120 ml
2/3 cup	= 5/3 fluid oz
	= 160 ml
3/4 cup	= 6 fluid oz
	= 180 ml
1 cup	= 8 fluid oz
	= 16 tbsp
	= 240 ml
1 pint	= 20 fluid oz
	= 600 ml
1 quart	= 33/8 fluid
	= 1000 ml
1 cup UK	= 10 fluid oz
	= 295 ml

Conversions of US Weight
measure to nearest gram:

4 oz	= 1/4 lb
	= 112 g
8 oz	= 1/2 lb
	= 224 g
12 oz	= 3/4 lb
	= 336 g
16 oz	= 1 lb
	= 448 g
32 oz	= 2 lb
	= 896 g

Conversions of
US length measure to
nearest centimeter:

1/4 inch	= 0.6 cm
1/2 inch	= 1.2 cm
1 inch	= 2.5 cm
12 inch	= 1 foot
	= 30 cm

Approx. Oven
Tempratures:

275°F	= 135°C
300°F	= 150°C
325°F	= 165°C
350°F	= 175°C
375°F	= 190°C
400°F	= 200°C
425°F	= 220°C
450°F	= 230°C
475°F	= 245°C
500°F	= 260°C

INDEX OF RECEPIES